THE THEATRICAL PRINTS OF THE TORII MASTERS

A Selection of Seventeenth and Eighteenth-century Ukiyo-e

By Howard A. Link

HONOLULU ACADEMY OF ARTS • RICCAR ART MUSEUM • 1977

Distributed by:

CHARLES E. TUTTLE CO., INC. with offices at Suido, 1-chome,
2-6 Bunkyo-ku, Tokyo, Japan, and Post Office Drawer F,
Rutland, Vermont 05701
ISBN 0-8048-1300-0

ROBERT G. SAWERS
5 South Villas, London NW1 9BS

Printed by Dobi Insatsu for

Riccar Art Museum, Tokyo and the Honolulu Academy of Arts, Honolulu

Designed by Joseph Feher, Honolulu Academy of Arts

Contents

Foreword

SHOZO HIRAKI

Director, Riccar Art Museum

The theatrical art of the Torii masters has long been prized for its intense forcefulness, and the school's splendid prints represent a series of memorable moments in the history of Japanese art. Whether it be the dramatic fury of an actor study or an elegantly conceived portrait of a courtesan, the results are among the most accomplished forms of graphic expression ever created.

Despite the Torii school's importance, this book represents the first monograph on the subject in a western language. Its preparation has been the devoted task of Dr. Howard A. Link, Curator of Asian Art at the Honolulu Academy of Arts and a recognized authority on the Torii masters. His wholehearted dedication to this undertaking is here gratefully acknowledged.

The exhibition, for which this monograph has been written, also has several firsts. Along with being the first notable exhibition in the West to deal exclusively with the Torii school, it also represents the first occasion for a unique example of international cooperation between an American and Japanese museum — the Honolulu Academy of Arts and the Riccar Museum, Tokyo. Both institutions have loaned their treasures to this joint exhibition and have served as administrative clearing houses for the loan of additional prints and books from collections in Japan and the West. This cooperation has resulted in the splendid panoply of ukiyo-e art recorded here — illustrated books and broadsheets of great aesthetic and historical importance. Some rare examples have never been seen in Japan while others are new to Western audiences. The material moreover is exhibited in the context of the present meaningful selection for the first time. It is hoped that these works will not only bring enjoyment, but enlightenment as well, and serve to encourage future research in this and related areas.

2

Author's Preface

HOWARD A. LINK

Curator of Asian Art, Honolulu Academy of Arts

This book describes and reproduces a selection of single-sheet Japanese woodblock prints and a few leaves of illustrated books published over a period of about one hundred years, from the 1670s to the 1760s. It is designed to accompany an exhibition dealing with the Torii family of ukiyo-e artists, who held a virtual monopoly over the production of theatrical illustrations for the Edo kabuki stage during much of this period. The works these artists produced, which also include paintings, posters, and kabuki programs, are termed *ukiyo-e*, meaning literally "floating world pictures" and can be equated in general terms with secular genre art in the West.

Beginning around 1700, the Torii school emerged as an active force in the illustration of kabuki subjects and established a standard in the representation of *yakusha-e* (pictures of actors) that was to prove so persuasive that dozens of later artists borrowed the formula. Their depictions can be divided into two distinct types: a quiet curvilinear illustration derived from the more polished and elegant acting tradition of Kamigata (the Osaka-Kyoto region), and the more forceful designs celebrating the bombastic drama of Edo-style kabuki. The origin and emergence of these important styles and their sophisticated adaption by succeeding generations of the Torii school is the subject of this text.

Drawn primarily from the holdings of the James A. Michener Collection of the Honolulu Academy of Arts, and the Hiraki Collection of the Riccar Museum, Tokyo, the selection is augmented by some superb works from the distinguished holdings of the Art Institute of Chicago; the Nelson-Atkins Gallery, Kansas City, Missouri; the Watanabe Collection, Tokyo; the Tokyo Bijitsu Library; the Werner Schlinder Collection, Switzerland and the Worcester Art Museum, Massachusetts.

Preparation of the catalogue has been a rewarding experience and the author wishes to thank, in particular, Mr. Mitsunobu Sato, Manager of the Riccar Art Museum, Tokyo, for suggesting the project and for his thoughtful cooperation.

The catalogue draws upon many sources, not the least of which is my own initial research of the early Torii masters conducted in the 1960s. Beyond this, I wish to acknowledge the many contributions received from friends and colleagues. Mr. Suzuki Jūzō and Mr. Roger Keyes, who helped research the Michener prints, are due primary credit for the many new kabuki identifications offered on subjects in the Michener Collection. A more complete discussion of these identifications will be noted in the Honolulu Academy of Arts' forthcoming catalogue of the Michener Collection

entitled *The Primitives*, also written by me in cooperation with the above-mentioned scholars. Repeated use of publications by Shibui Kiyoshi, Yoshida Teruji, Narazaki Muneshige, Takahashi Seichiro, Toda Kenji, Takano Tatsuyuki, Kuroki Kanzō, Inoue Kazuo, and Richard Lane must also be acknowledged, for I have relied heavily on their scholarship.

The lenders to this exhibition, listed elsewhere, have all been extremely generous and cooperative; expressions of sincere thanks are offered to them all.

Among the many Academy staff members who helped, primary recognition must go to Mrs. Anne Seaman for her patient and skillful editing and to Mrs. Evelyn Ng who courageously coped with the typing of the lengthy manuscript. I also wish to express my gratitude to Mr. James Jensen, Mrs. Reiko Brandon, also of the Academy, Mr. Peter Morse and Dr. James Brandon, specialists in ukiyo-e and kabuki respectively, for their careful reading of the manuscript. The valuable suggestions and corrections they provided is acknowledged with gratitude. I also wish to extend a special thanks to my long time friend, the ukiyo-e specialist, Mr. Charles H. Mitchell. Without his generous and thoughtful cooperation over the past several years the present catalogue would not have been possible. Finally, I would like to express my sincere thanks to Mr. James Foster, Director of the Honolulu Academy of Arts, for his kind support and encouragement throughout this undertaking.

Note: This project was brought to fruition through the kind cooperation of Mr. Toshiyuki Higuchi of the International Cultural Exchange Center, Tokyo; his efforts are acknowledged here with gratitude.

Lenders to the Exhibition

ART INSTITUTE OF CHICAGO, *Chicago, Illinois*

HIRAKI COLLECTION, RICCAR ART MUSEUM, *Tokyo, Japan*

HONOLULU ACADEMY OF ARTS, *Honolulu, Hawaii*

† TOKYO GEIJITSU LIBRARY, *Tokyo, Japan*

WATANABE COLLECTION, *Tokyo, Japan*

WILLIAM ROCKHILL NELSON GALLERY AND

ATKINS MUSEUM OF FINE ARTS, *Kansas City, Missouri*

WERNER SCHINDLER COLLECTION, *Switzerland*

WORCESTER ART MUSEUM, *Tuckerman, Massachusetts*

† *Japan only*

6

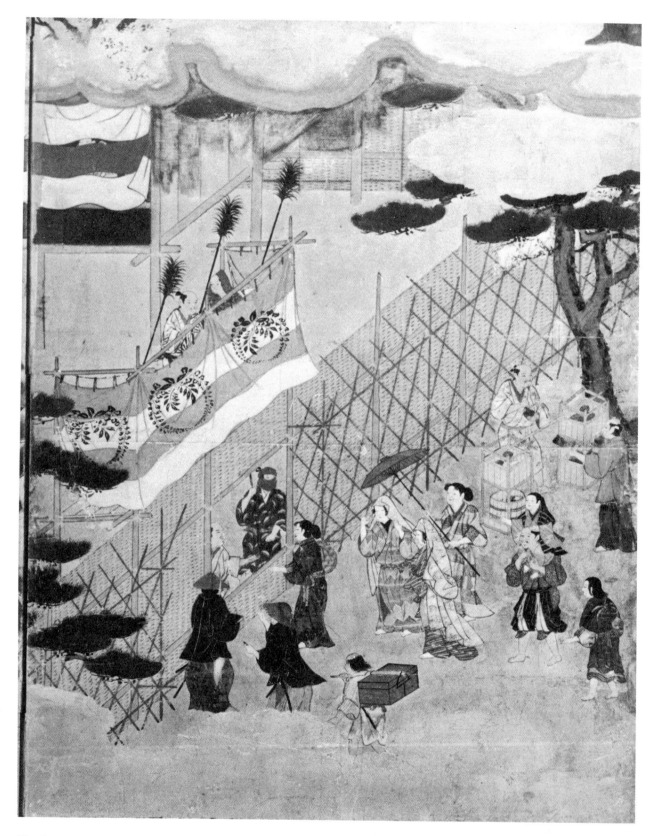

Fig. 1
KABUKI SCENE (detail)
Fragment of a larger composition, ink and color on
paper with gold leaf mounted as a small two-fold
screen. Date: ca. 1650s. Courtesy, The Richard
Lane Collection.

The Social and Cultural Setting

It was the decisive battle of Sekigahara in 1600 and the defeat of generals who had given their allegiance to Hideyori (1593-1615) that marked the beginnings of a new age for Japan and the rise of the battle's victor, Tokugawa Ieyasu (1542-1616).[1] In 1603 Ieyasu assumed the title of *shōgun*, ushering in the longest reigning dynasty of military dictators in the history of Japan. The seat of this new dynasty was not ancient Kamakura, nor the classic city of Kyoto where the powerless Emperor maintained his residence, but rather the crossroads of Edo. The selection of this small village was as much a final gesture of ridding temporal government of the Emperor's spiritual hold as it was a military expediency. Edo was situated at the eastern end of the broad and empty lands of the Kantō plains in eastern Japan where Ieyasu maintained his feudal fief. Within a few years, trivial Edo was transformed into a lively, thriving capital with a shōgunal castle surrounded by vast moats; business, shopping and entertainment districts; residential areas; and even a prostitute district outside the city limits called the Yoshiwara. More than half a million people resided in the hurly-burly that was Edo by 1700.

Ruling with an iron hand, the Tokugawa shōguns forced the *daimyō* (feudal lords) and their vassals to pay allegiance to the government. As a result, Edo virtually swarmed with the retinue of the feudal lords along with transient samurai, particularly of the *rōnin* class (unattached warriors). The government, moreover, required all *daimyō* to keep residences in Edo, and to assure their continued loyalty, parts of their families were forced to remain as nominal hostages. Periodic changes in population were therefore not uncommon, with the main balance of citizens being men. The result was an atmosphere of youthful brashness, quite distinct from other cities, to which the adventurous spirits of the time were drawn.

The Tokugawa shogunate ruled Japan for 265 years (1603-1868). It was not until the political collapse of this regime and the restoration of the Emperor that Edo's name was changed to Tokyo, meaning literally, the Eastern Capital. The appellation, Edo, was also used to define the age of the Tokugawa dictators, and, like periods preceding it, the Edo period was divided into a number of important *nengō* or eras. The names of these eras were often changed with the permission of the Emperor out of some superstitious belief that a fresh designation would usher in a happier, more prosperous time. The custom was abandoned following the fall of the Tokugawa regime.

The Edo period came on the heels of a turbulent age of successive wars. Since it was a relatively

peaceful time, the populace was at last able to give vent to its long suppressed need for identity. While the Tokugawa shogunate and *daimyō* courts busied themselves with their somnolent aristocratic life, a new class of merchants or *chōnin* began to emerge with their own fascinating social milieu. The chōnin were to become the very soul of Edo.

This class development was one consequence of the urban center growth and the final spread of wealth to the cities from the *daimyō* controlled agricultural lands. The effect was one of financial erosion for the top-heavy feudal heirarchy. Their wealth was ending up in the pockets of the landless and virtually tax exempt merchants. To counteract the rise of this powerful middle class, the Tokugawa government periodically passed a number of repressive laws aimed at curbing the new class's ostentatious behavior. Laws were even created in which large chunks of chōnin wealth were arbitrarily seized. In the end these attempts proved futile.

The history of the Edo period is thus marked by contrasting eras of extravagant debauchery, when the merchant class in desperation and daring lived in open defiance of a social system that gave them no place, and periods of strict sumptuary laws, during which the government ruthlessly attempted to regain supreme control. This struggle is well reflected in the arts of the merchant class; their kabuki theater was violent and passionate as was their literature, while their genre art was either richly seductive or full of force and bombast. Indeed, the common arts came to symbolize the *chōnin* class struggle. It is no wonder that their art forms were officially despised and ruthlessly repressed by the government and the aristocracy.

The illustrious nengō called "Genroku" (1688-1703), or the era of the "Origin of Good Fortune," saw the maturation of the middle class arts. The common citizenry demanded a beauty and aesthetic of its own, and the period's creative geniuses were quick to respond. Japan's foremost playwright and dramatic poet, Chikamatsu Monzaemon (1653-1724); the famed author of hedonistic novels, Ibara Saikaku (1642-1693); and the sensitive haiku poet, Matsuo Bashō (1644-1694) constituted a trio of the most illustrious writers of the day. Yuzen (active 1710) and Ōgata Kōrin (1661-1716), were the personifications of the age's decorative movement. It was Kōrin, the great Rimpa artist, who gave this movement direction and personality, while Yuzen provided the world with a unique resist-dye method for fabrics, making possible the richness and abandon of Edo period kimono. It is in this era that both kabuki (the Japanese popular theater) and ukiyo-e (Japanese genre art) found the freedom

for creative growth.

Although the history of kabuki and ukiyo-e has been considered by other writers, a brief summary of some of the more significant events leading up to the emergence of the Torii school is appropriate here. Credit for the beginning of kabuki goes to a female shrine dancer from Izumo named Okuni. Around 1600, the very year of Hideyori's defeat by Ieyasu, she performed a Buddhist ceremonial dance in the dry bed of the Kamo River in Kyoto. With erotic variations all her own, she became an immediate success and quickly attracted a group of pupils, both men and women, who formed a company. The new theater was little more than a bawdy dance review and quickly earned the somewhat uncomplimentary name, *Okuni Kabuki*. The term, derived from the verb *kabuku*, "to tilt forward," extended metaphorically in early Edo slang to signify customs or behavior that defied the traditional norm and drew attention. As with the word *ukiyo*, the term was imbued with overtones of the licentious and hedonistic. Rival troupes known as *onna kabuki* were in fact composed of "easy" women. Adverse effects on public morals were considered so great that finally, in 1629, the shogunate was forced to issue a decree prohibiting all women on the stage. With the prohibition of women, young men of bisexual conduct known as *wakashu*, were given free rein in a variety of roles including *onnagata* (female impersonators). These male youths eventually proved as great a source of attraction as the women, so that in 1652 the shogunate again suppressed the theater. After this, actors were compelled to shave off their forelocks to lessen their effeminate charms—but that special distinction proved to make the *onnagata* even more attractive.

Profound changes in the actual form of the drama itself followed. Officially the newly formed theater was referred to as *monomane kyōgen zakushi* (spoken drama with mime or imitation) but was commonly known as *yarō-kabuki*. The word *yarō* meant "man" or "fellow" with the implication that the new kabuki was now being performed by robust men of adult age. Eventually, the word *kabuki*, always written in *kana* syllabic script at this time, would be rendered in Chinese ideographs meaning "song, dance person," but the dates of this change which involved at least two transitional steps is by no means certain.[2]

In any event, skillful acting of both male and female roles became necessary, and scenarios which had previously been nothing more than a type of revue took on an orthodox pattern (Fig. 1). Each actor began to specialize in one particular kind of role and in 1664 plays were divided into more

10

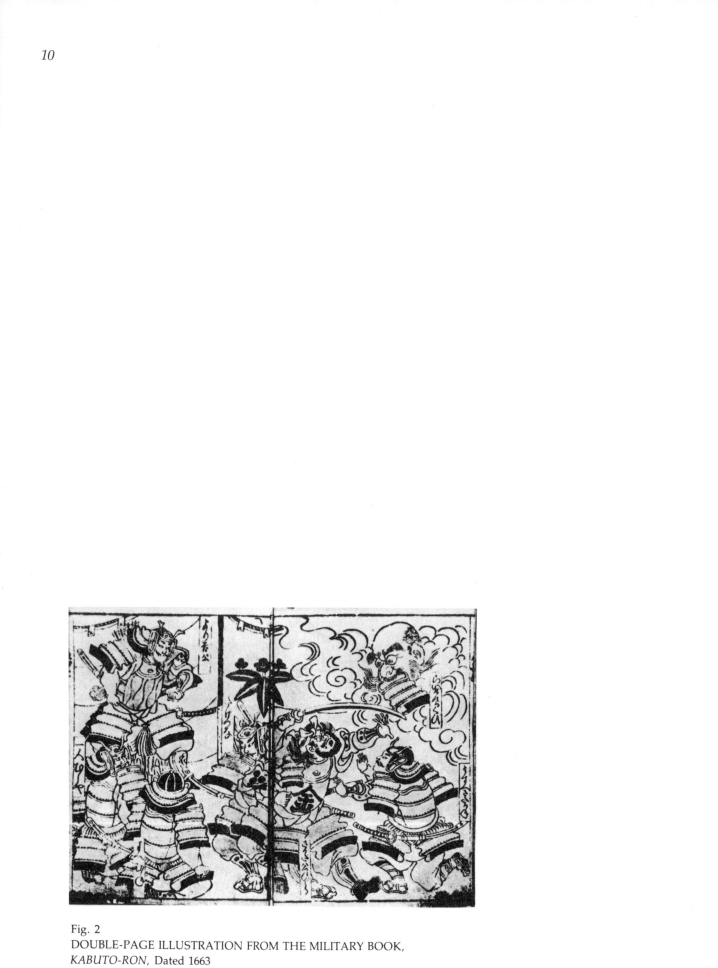

Fig. 2
DOUBLE-PAGE ILLUSTRATION FROM THE MILITARY BOOK,
KABUTO-RON, Dated 1663
(After *Nihon Hanga Bijutsu Zenshu*,
Vol. II, No. 93, Kodansha, 1961.)

than one act.[3] These acts were eventually distinguished as *jidaimono* (historical drama) and *sewamono* (domestic drama) and often included a *shosogoto* (dance play) as one of the acts. They were performed either as separate acts of a play or as independent plays of a uniform type.

The leading actor of *sewamono* during this golden era was Sakata Tōjūrō I (1647-1709), who developed the soft, elegant and essentially realistic acting style of Kyoto kabuki. Specializing in the so-called *tachi-yaku* (leading male roles), his greatest successes usually were in the portrayal of *chōnin* and their involvement with life in and around the Shimbara pleasure quarters of Kyoto. His style of acting, known as *wagoto* (soft stuff), was to influence the entire school of Kamigata (Osaka/Kyoto) actors including among others the great Nakamura Shichisaburō (active 1700-1710) (see No. 103).

Nearly simultaneous with the development of Tōjūrō's elegant approach to acting and the *sewamono* play was the bombastic and totally unrealistic acting tradition of Ichikawa Danjūrō I and his *jidaimono* scenarios. This vastly energetic man was a giant on the kabuki stage and was the founder of the ranking dynasty of actors in Edo.

In 1673, young Danjūrō, then only fourteen years old, played the part of Sakata no Kintoki, a warrior in the play, *Shitenno Osanadachi (The Childhood of Four Strong Warriors)*. It was the first instance of the *aragoto* (rough stuff) acting style that was to be so important to Edo kabuki.[4] His style of acting, which required a tremendous amount of swaggering about as some swashbuckling hero, was based largely on characteristics of the imaginary superhuman Kimpira, as told by street chanters in a narrative called *Kimpira-bushi*, a kind of exaggerated storytelling which was in fashion in Edo around this time. This storytelling dealt with the heroic exploits of this legendary hero and involved the use of elaborate dolls. Although none of these dolls exist today, a number of illustrations survive, many done for the military storybooks appropriately referred to as *kimpira-bon* and attributed to nameless woodblock masters of Kyoto in the 1660s (Fig. 2).

Danjūrō's achievements are well described in kabuki record. The exposed portions of his body and face were painted entirely in red with black lines drawn on top to delineate and emphasize his features. His large, fierce eyes were accentuated and his eyebrows were painted with bold upturned strokes to symbolize vitality. All this was borrowed from the Kimpira puppet tradition and would seem to be the crude beginnings of *kumadori* makeup. Such symbolic makeup was eventually to be distinguished by the use of bold alternating lines drawn in a kind of striped pattern, and is still in

use today to identify the *aragoto* hero.

Stage successes followed in quick succession, many written by Danjūrō himself under the pen name Mimasu Hyōgo. Not content with the primitive and simple stories that typified the early *jidaimono,* his plots took on a greater maturity and complexity. In 1684 he wrote and acted in his first staging of a drama about Saint Narukami, the monk who caused the rain to stop falling throughout Japan. He made extensive revisions to this drama in 1698, and the work eventually became the best of all Genroku era plays (No. 99). Four years later, in 1688, he produced his first *Kongen Soga,* based on the heroics of the legendary Soga brothers and their attempt to revenge their father's murder. This play was the prototype for a long succession of dramas dealing with the Soga theme (Nos. 20-22, 26, 97).

The following brief sketch, taken from Act I of the 1697 production of *Tsuwamono Kongen Soga,* as it is summarized in the *eiri kyōgen bon* (kabuki picture book) of the play published in the same year, offers an early example of the type of hedonistic plot which appealed to Genroku audiences. This play was written by Danjūrō I at the height of his career.

The main theme of the act is a four-sided, bisexual love affair involving the protagonist Soga no Jūrō, his boyfriend Koshirō, the damsel Otome no Mae, and the villain Genta Kagesue. In the opening scene, Jūrō is found praying at a Shintō shrine for the success of his impetuous brother Gorō in an attempt to revenge their father's death. In his prayers, he also makes reference to his strange love for the young boy Koshirō, (in those days there was no moral stigma attached to sexual inversion) and enlists the gods to help him win his affection.

At this point, the young maiden Otome no Mae appears and soon confesses to Jūrō that she too loves the same boy, asking Jūrō to intercede in her behalf. Jūrō reluctantly agrees to help her by first becoming the boy's lover. Finally, Koshirō appears and submits unabashedly to the idea of a triangular love affair. The act is brought to a close when the villain Genta bursts on the scene to announce his love for Koshirō also. In a fit of anger, he stomps off the stage upon learning that Jūrō and Otome no Mae had already won the popular bed partner for themselves.

Such was the flavor of much of kabuki in those days—little more than a domestic soap opera. These trivial plots, however, served the actors well, as a fitting framework upon which they could hang their polished acting techniques.

In 1697 the great Danjūrō introduced five major acting *kata* (acting bits) in the Nakamura-za theater production, *Sankai Nagoya.* These unique sequences proved so successful that they were subsequently incorporated into a number of kabuki plays and have been retained to this day. It is with this same performance that we encounter the first full-blown instance of Torii style art in the illustrated book commemorating the *Sankai Nagoya* performance (No. 96).

Thus, by the Genroku period, the division in kabuki style acting was complete: Kamigata-trained actors offered a polished and elegant style of realistic acting and favored the *sewamono* while Edo actors specialized in the rough bombastic acting style and the *jidaimono* scenario. This distinction is important to an understanding of the art of the early Torii masters, for by the late 1690s, when these artists began to dominate the print world, a definite interrelationship between the ukiyo-e woodblock print and kabuki existed. In fact, many of the memorable performances were recorded in books, albums and broadsheets by these illustrious masters, apparently under some kind of special arrangement with the theaters of Edo: the Nakamura-za, the Yamamura-za, the Ichimura-za and the Morita-za.

It was in the 1660s that woodblock artists, drawing upon centuries of technical know-how in Buddhist woodblock prints, abandoned the formal mannerisms in composition that characterized earlier efforts in order to produce truly expressive illustrations. At this time the *Ukiyo Zōshi* or "floating world storybook" of Osaka/Kyoto and Edo appeared. It dealt with the common people's fads and amusements, especially stories surrounding the prostitute districts. The often quoted meaning of the word *ukiyo* with its distinct hedonistic overtones affords repeating here: "Living only for the moment, gazing at the moon, snow, cherry blossoms and autumn leaves, enjoying wine, women and song, and just drifting along with the current of life, like a gourd floating down a river."[5] So it was that the brothels, the theaters, the sumo arenas, the pleasure resorts and the numerous street scenes became the constantly recurring theme of the book illustrators. In contrast to such illustration, it is thought that the development of the independent broadsheet was related to the publication of mid-seventeenth century erotic albums patterned after Chinese prototypes. This is suggested by the undeniable fact that the bulk of the earliest surviving illustrations in this format deals exclusively with the erotic genre.

It should be pointed out, moreover, that from the beginning these early prints were not just an

inexpensive reproduction of an existing art style. It was rather a whole new art form, with its own aesthetic quality quite distinct from traditional Japanese painting or earlier seventeenth century woodblock illustration for books. Initially, most of the ukiyo-e prints were unsigned but many have been stylistically related to signed books by known artists, making attribution possible.

Two predecessors of the Torii artists need mentioning here. Hishikawa Moronobu (?-1694) was a young man of such brilliant capacity that his contemporaries selected him as the founder of the ukiyo-e school. He was, in fact, the first known ukiyo-e artist of great stature to sign his work, although it is clear that several competent masters preceded him at least as early as the 1660s. Speculation has it that Moronobu, the son of a fabric dyer from Kyoto, may have come to Edo before the Manji era (1658-1660). Unfortunately the great fire of 1657 destroyed most of the city and with it any documentation that might have substantiated his arrival. The many early attributions to him of Edo works dated in the 1660s, moreover, including two famous books of erotica, have since been reassigned to other artists, including the Kambun master, a name devised by Dr. Richard Lane to identify the hand of an unknown master of the Kambun era (No. 92).

Moronobu's signed and dated book, *Buke Hyakunin Isshu (100 Poet-Warriors Illustrated)*, of 1672 appears to be the master's earliest surviving art (No. 1). His illustrations, while not actual portraits of warrior poets, are imbued with a vitality which helps to set this master apart. Although Moronobu excelled in the art of book illustration, particularly erotica, it is his great album designs of the 1680s that represent his finest work. The sweeping overall splendor of his compositions featuring courtesans, with decorative emphasis on the kimono, is typical Moronobu's fully developed style and strongly influenced his contemporary competitor, Sugimura Jihei (active 1680-1695), as well as a number of important followers including the first Torii masters.

It is necessary for the reader to recall the role of the courtesan in Japan. During an age when there was no social place for a woman outside the rigor of an arranged, often romanceless, marriage, the high ranking courtesan became a symbol for all that was mystical and provocative in womanhood. The courtesans were resplendent princesses within the walls and stratified social make-believe of the entertainment districts. They attained their rank by virtue of their beauty and accomplishments; at the top were the *tayū*, then came the *kōshijorō* and *misejorō*. These are the women that the print artists showed in their pictures of the day—much as a Western "pin up," but

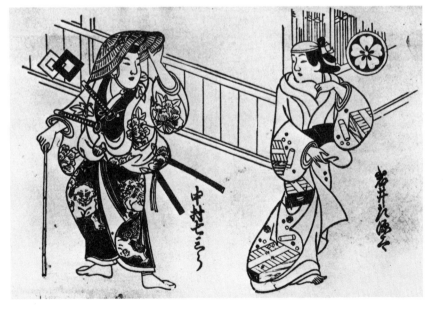

Fig. 3
ALBUM SHEET SHOWING NAKAMURA SHICHISABURŌ I
and IWAI SAGENDA
Attributed to Torii Kiyomoto by
Yoshida, Date: 1688-1693
(After *Nihon Hanga Bijutsu Zenshu*,
Vol. II, Fig. 134, Kodansha, 1961.)

with greater elegance. Moronobu and Sugimura were surely among the first to glamorize the *grand dame* of the brothels, paving the way for later depictions by the Torii and Kaigetsudō artists.

Woodblock illustration dealing with kabuki can be traced back to as early as 1675. The dated play bill in the exhibition and reproduced here is possibly the oldest document of its kind. It reveals a perfunctory type of illustration associated with one of the nameless masters working at the time of Moronobu (No. 93).

Of particular interest to the study of the origins of the Torii style are a small group of album sheets depicting actors, including Nakamura Shichisaburō I and Iwai Sagenda, dated between 1688 and 1693 (Fig. 3). In these bold black-and-white album leaves we encounter one of the earliest instances of an attempt to illustrate the soft elegant Kamigata acting style. The *wagoto* figure of Shichisaburō I and the *onnagata* Sagenda are both drawn in a curvilinear and decorative manner that would be borrowed by the first Torii artists in their kabuki depictions of the Kamigata tradition. The origins of this type of illustration may have been Kamigata based; the style was to persist in the woodblock art of Kyoto artists such as Yoshikiyo (active 1700) (No. 100 and No. 101) and can be observed in several superb paintings of early kabuki subjects executed by nameless *machi-eshi* (town painters) of the day (Fig. 1).

In contrast, one of the more obvious sources for the vigorous Torii illustrations celebrating the *aragoto* are the military storybooks (Kimpira-bon) of the 1660s published first in Osaka and Kyoto. Beyond this, the huge Buddhist guardian figures of Kamigata's many temples must have served as the ultimate inspiration. We reproduce a double-page illustration from the book, *Kobuto-ron,* dated 1663 (Fig. 2). The expressive manner of drawing, the composition, the figure types and above all the dramatic posing are closely related to the earliest Torii depictions occurring in *kabuki* storybooks. These two diverse styles, inspired by regional traditions, eventually appeared side by side in the Edo *eiri-kyōgen-bon* of 1697, commemorating the first Danjūrō's great theatrical successes, *Sankai Nagoya* and *Tsuwamono Kongen Soga* (Nos. 96 and 97). Although unsigned, these important books may very well be the creation of the early Torii masters and mark the true beginnings of the two styles associated with the school.

So it was that by the late 1690s everything was available for the first Torii: the woodblock tradition of Moronobu and Sugimura with their erotic prints and sensual portraits of the leading

courtesans; the elegance and vigor of Kamigata and Edo kabuki as seen in the newly developed *wagoto* and *aragoto* acting traditions and a number of unsigned woodblock illustrations that delineate, with varying degrees of success, the temperaments of these two acting traditions.

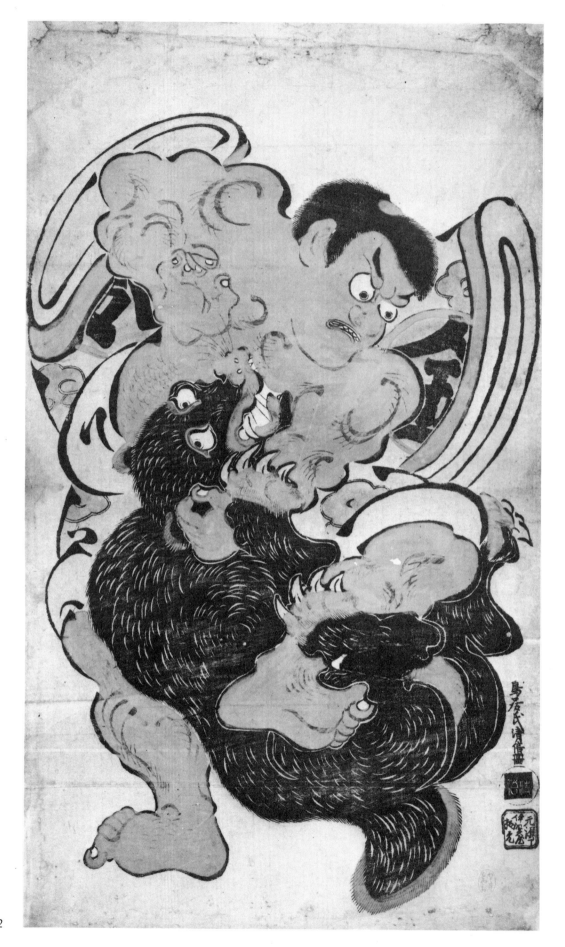

The Early Torii Masters

Shortly after the great Hishikawa Moronobu passed from view, and coinciding with the spectacular stage achievements of Ichikawa Danjūrō I in the late 1690s, the Torii masters with their vigorous illustrations of kabuki actors emerged. The development of the Torii style has long been credited to the school's nominal founder, Torii Shōbei Kiyonobu (ca. 1664-1729), who arrived in Edo from Osaka in 1687. With the support of his actor-father, Shōshichi (Kiyomoto) (1645-1702), who possibly painted kabuki advertisements in between acting assignments but left no extant signed woodblock prints, young Shōbei began to issue books, prints and signboards in the 1690s. Around 1698, he adopted the name Kiyonobu, perhaps in recognition of his success. The oral tradition of the Torii family, as well as a variety of records, including a history of the Torii family compiled in the Meiji period titled the *Torii ga Keifu (kō)* and the *vade mecum* of ukiyo-e studies, the *Ukiyo-e Ruikō* (a biographical history known in several different manuscript editions), all agree that Torii Shōbei Kiyonobu was the first official Torii.[1] Tradition has characterized his art on one hand as vigorous and energetic and, on the other, as decorative and quiet. The first style was conceived for the tremendous pictures of swashbuckling Edo actors while the second manner was reserved for the depiction of the more sedate Kyoto actors as well as a number of statuesque courtesan portraits.

Kiyonobu's first signed and dated works, two 1697 illustrated books, are, for the most part, uninspired and routine.[2] The master's earliest signed kabuki broadsheet of the next year, however, is exciting and innovative (see No. 2). Following a new format, possibly introduced by Sugimura in the mid-1680s, the large print depicts in a quiet polished manner the star *onnagata* of the performance, Sawamura Kodenji, in the role of Tsuyu no Mae performing a kyōran (lunatic dance) before Tadasu Shrine. An unsigned picturebook of the same play, *Kantō Koroku*, dated in the colophon to 1698 confirms this identification (No. 98f). Here for the first time we encounter on a large scale Kiyonobu's primary style—a quiet decorative treatment derived from the more polished and elegant tradition of kabuki in Kamigata. Quite clearly, Shōbei and his father, Kiyomoto, had grown up in this acting milieu and knew it well.[3]

This fine print and, for that matter, the majority of illustrations contained in the theatrical picturebook of the play are stylistically similar to Kiyonobu's great album achievements of 1700, *Fūryū Yomo Byōbu* (No. 3) and *Keisei Ehon*.[4] In the former, we encounter Kiyonobu's quiet, decorative treatment in the depiction of kabuki actors. From this early work, which is a pastiche of famous

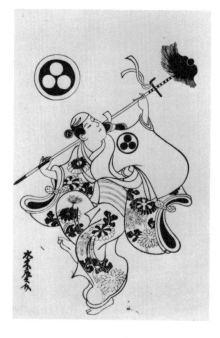

Fig. 6
ILLUSTRATION OF MIZUKI TATSUNOSUKE IN THE YARI-ODORI DANCE
FROM *FŪRYŪ YOMO BYŌBU*
Signature: Yamato gakō Torii Shōbei Kiyonobu zu
Technical: Sumizuri-e; medium-size ehon
Date: Genroku 13 (1700)
Courtesy, Museum of Fine Arts,
Boston, Morse Collection

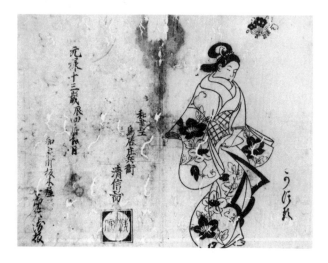

Fig. 4
ILLUSTRATION AND COLOPHON FROM
KEISEI-EHON (Provisional title)
Signature: Yamato gakō Torii Shōbei Kiyonobu zu.
Technical: Sumizuri-e; medium-size book.
Publisher: Hangi-ya Shichirobei. Date: Genroku 13 (1700)
Courtesy, Ryerson Library of
the Art Institute of Chicago.

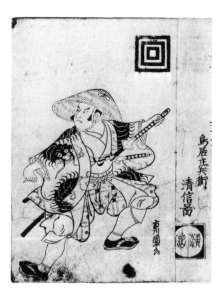

Fig. 5
ILLUSTRATION OF ICHIKAWA DANJŪRŌ I
FROM *FŪRYŪ YOMO BYŌBU*
Signature: Yamato gakō Torii Shōbei Kiyonobu zu
Technical: Sumizuri-e; medium-size ehon
Date: Genroku 13 (1700)
Courtesy, Museum of Fine Arts,
Boston, Morse Collection

actors of the past and present in their most celebrated roles, a typical page shows Ichikawa Danjūrō I in a scene from the 1697 production of *Sankai Nagoya* presented three years earlier at the Nakamura-za (compare Fig. 5 with No. 96h). There is only a glimpse of the spontaneous and bold rendering that one might expect in these album illustrations of 1700; instead, Kiyonobu's designs tend to be more quietly decorative. This is even true in the case of Kiyonobu's rare depictions of the exaggerated *aragoto* roles of the Edo actors. From the very beginning, this master favored full, rounded forms both in the outlines of his figures and the blunt curvilinear motifs of his costume detail. Indeed, the grandiose element in these illustrations is much less pronounced than the bravura found in other Torii-style works of the same period. His brushline, moreover, while bold and thick like that of a poster painting, lacks the tour-de-force calligraphic virtuosity of other contemporaneous illustrations attributed to the Torii.

Incidentally, the rendering of the classic *yari-odori* (acrobatic spear dance) from the same album (Fig. 6) must have been a favorite of Kiyonobu; a few years later, when another Kamigata actor chose to perform the dance at his Edo debut Kiyonobu again made an illustration, but this time in the large hand colored broadsheet format that has become so popular (No. 104). In fact, all of his masterful early designs reveal an artistic temperament quite different from the bold illustrations that represent both the early Torii tradition and Edo-style kabuki.

Kiyonobu's depiction of solitary Yoshiwara beauties in his other great album series of 1700, *Keisei Ehon*, offers striking proof, however, of the master's pre-eminent position in the Torii school. In each of the eighteen portraits the courtesan is gorgeously clad and has the distinct Torii face-type that is almost devoid of emotion. Each is a masterpiece, perfect in composition, drawn with a sinuous ink line that virtually sings on the page. Reproduced here is a portrait of a courtesan named Kaoru, identified by crest and inscription, whose form seems to live and move with the slight blurring of the soft heavy ink line (Fig. 4). So successful was Kiyonobu's achievement that this book was quickly pirated in the next year, and finally used as a model by another important contemporary artist, Okumura Masanobu (ca. 1686-1764) (No. 27). The general style, moreover, was to serve as the basis for the numerous courtesan portraits by Okumura Masanobu, Torii Kiyomasu and the Kaigetsudō masters in succeeding years. This dazzling black-and-white book of courtesans insured Kiyonobu an enduring position in the history of ukiyo-e.

From a study of this and related material, the date, 1700, would appear to be the year that young Shōbei emerged from the ranks of students to become an artist of some merit. His age at this time was thirty-six, if the surviving records of his birth are correct.[5] His artistic development would, therefore, seem to be a relatively slow one. *Shunga* (erotica) albums by Kiyonobu began to appear between 1700 and 1711 and along with some splendid broadsheet prints of actors, this body of work constitutes his finest large scale woodblock art. A fine example of his fully developed style, in this exhibition, is the study of a courtesan painting a screen while her lover looks on (No. 4). This bold black-and-white sheet, one of twelve from a *shunga* album, combines dramatic strength, clarity, and fine drawing with a sense of poetic charm. By 1709 Kiyonobu's paintings of kabuki actors had gained such popularity that they were placed in Shintō shrines as a substitute for the *ema* (votive painting on wood). One contemporary says of his art: "Shōbei's style was well-suited to kabuki and his actor pictures were to be seen in all the shrines . . . Shōbei captured the character's emotions perfectly. Everyone who visited the shrine was impressed by his pictures and crowds were always to be seen standing around in admiration."[6] Few such paintings survive to document his brush style, but those that do invariably follow his quiet manner. Indeed, among his signed surviving works, whether paintings, prints or book illustrations, there seems to be a surprisingly small number of designs celebrating the grandiloquence of Edo-style kabuki. Those that attempt this grand style never reach the classic extreme—one highly explosive and nervously conceived—for which tradition says he should be credited.

This anomaly is usually explained by the notion that Kiyonobu spent most of his time at the more prestigious business of painting kabuki billboards and designing playbills and illustrations, all of which have been long since lost.[7] While surely this ready solution explains the scarcity of his art in general, it does not resolve the fact that very few illustrations of a bold, spontaneous nature had survived. This is particularly significant when compared to the oeuvre of his many followers who produced, seemingly at will, either the quiet or bold tradition of kabuki illustration.

This is especially true of an artist who was probably not a follower but a contemporary—the enigmatic Kiyomasu (active 1697-1720), whose actual identity remains one of the most tantalizing mysteries in all of ukiyo-e. Kiyomasu's numerous prints—many unqualified masterpieces—are basically of two types: some are done in the quiet style of Kiyonobu and are almost indistinguishable,

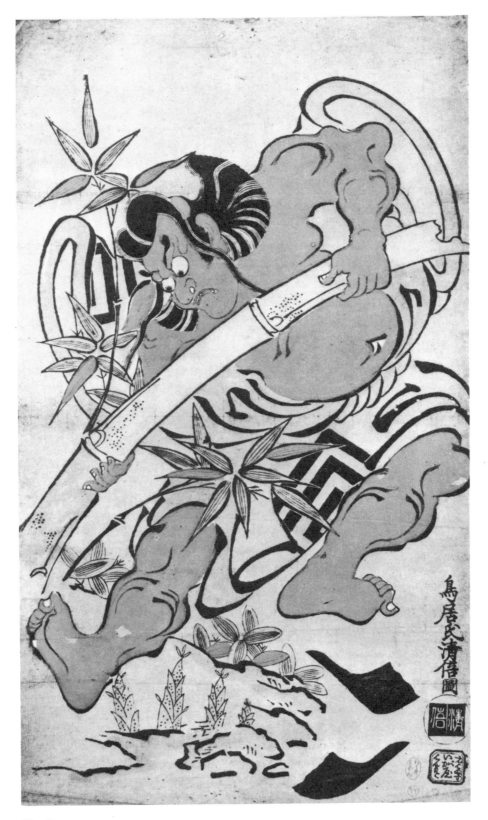

Fig. 7
ICHIKAWA DANJŪRŌ I AS SOGA NO GORO IN THE PLAY,
TSUWAMONO KONGEN SOGA, PERFORMED AT THE NAKAMURA-ZA
IN THE FIFTH MONTH OF GENROKU 10 (1697)
Signature: Torii Kiyomasu, Seal: Kiyomasu
Technical: Kakemono-e; tan-e, Publisher: Iga-ya
Courtesy, Tokyo National Museum.

save for a generally lighter, more graceful touch; others are done in a furious line and striking color, and are virtually unmatched by any of his contemporaries. (Compare Nos. 15, 17 & 18 done in the calm style with Nos. 12, 13 & 14 done in the bravura style.) Yet, despite the strength and versatility of his art as well as the relatively large number of examples that have survived, absolutely nothing is known of this long-forgotten master. Aside from his use of the same surname, Torii, no firm genealogical connection has ever been positively proven between Kiyonobu and this shadowy genius. Indeed, one early critic, Fritz Rumpf, perhaps for lack of any other evidence, seriously proposed that Kiyonobu and Kiyomasu were actually one and the same person.[8] Others, more discerning, noted subtle differences in style and concluded that Kiyomasu must have been a son or brother of Kiyonobu. Of these theories, only the one identifying Kiyomasu as a son of Kiyonobu gained general acceptance for a time, but even this identification now appears unlikely.[9]

All that is certain at this juncture is that Kiyomasu, the artist, did indeed exist.[10] We can be confident of his flesh and blood status, despite the total absence of his name in any contemporaneous record, for not only did he produce signed prints but signed playbills of the Edo kabuki stage as well (No. 20). Such theatrical documents preclude the possibility of Kiyomasu being a publisher's invention to dignify pirated prints, as in the case of the fictional Mangetsudō some two decades later.

It is in the art itself that we find our only satisfactory evidence for a study of the elusive Torii Kiyomasu. The key surviving art of this shadowy master is a group of very large handcolored prints showing scenes of violent action on the kabuki stage. Art of this type had been previously dated to around 1715, but recent research now supports the opinion that some of the more technically primitive prints, all published by the early entrepreneurs, Iga-ya and Emi-ya, celebrate plays performed in the late 1690s and early 1700s. It is this group of exceptional prints that has caused considerable excitement and controversy in academic circles. Their dating disputes the traditional view that Kiyomasu was a son of Kiyonobu as Kiyonobu did not marry until 1694, and challenges Kiyonobu's credibility as the master to originate this important bold style of ukiyo-e art.

The oldest broadsheet in the group, which the author prefers to define as part of Kiyomasu's misplaced early style, depicts Ichikawa Danjūrō I as Soga no Gorō uprooting bamboo (Fig. 7). This print, now in the Tokyo National Museum, celebrates a famous scene from the Nakamura-za

production of *Tsuwamono Kongen Soga* of 1697 in which Danjūrō gives his Edo audience a spectacular taste of his Kimpira-inspired acting. This performance came on the heels of *Sankai Nagoya*, mentioned earlier, and after an absence from the Edo stage during which time Danjūrō further perfected his *aragoto* technique.[11] The sympathetic audience went wild in their enthusiasm for his acting. Kiyomasu's souvenir of the performance, a huge broadsheet drawn in a style recalling the Kimpira-bon illustrations of the 1660s crackles with excitement. In a frenzy, Gorō uproots a huge bamboo and leaps into the air; his extended left leg, naked belly, distorted face, and straining arms are painted in a fiery *tan* (red-orange). In this great print, moreover, we encounter for the first time on a large scale the two powerful characteristics for which later critics would coin epithets: *hyotanashi* (gourd legs) and *mimizukaki* (wriggling worm lines). The former were supposed to create an illusion of violent strength, and the latter were used to represent twisted vigor. Evidence of this important print's early date was recently uncovered by the discovery of a picturebook of the very play in question dated to 1697. This evocative record, showing the masterful performance of Danjūrō and other consummate actors of the Nakamura-za stage company, includes a variant illustration of the same powerful scene drawn by an undetermined Torii artist—perhaps Kiyomasu himself (No. 97e). The book, however, may be a collaboration, for other illustrations seem closer to the calm, more decorative style of Kiyonobu. We will never know positively since this and other Torii-style books of the same period are all unsigned.[12] Four such books have been selected for this exhibition.

The second broadsheet by Kiyomasu, recently acquired by the Honolulu Academy of Arts, is breathtaking. The print, although not known to be associated with a kabuki performance, can be dated on the basis of style, signature and technical matters to around 1700, and depicts the heroic strongman, Sakata Kintoki, wrestling with a huge black bear (No. 12). Kintoki, also known as Kintarō, grew to enormous strength and was often the subject for Torii artists in their ornate portrayals. This print, rendered in furious line and brilliant *tan*, would seem to be the earliest known example of this theme done by a Torii artist. It might be remembered that it was the bravura and swagger of the Edo storytellers and their narrations of another superhuman hero, Kimpira, that gave Danjūrō his idea for the new *aragoto* style of acting. This, in turn, inspired Kiyomasu to create his powerful prints.

Still a third tour de force in this early group of broadsheets, colored in swashbuckling

orange-red, yellow, subdued olive-green and pale blue is the Nelson-Atkins Gallery print showing Ichikawa Danjūrō I and Yamanaka Heikurō in the act of ripping apart an elephant (No. 13). This magnificent design, signed and sealed Kiyomasu, reveals the same powerful drawing, swirling line and uncanny placement as the previous imposing print. It can be securely dated to the 1701 production of *Keisei Ōshokun*, the only recorded instance of this particular play. Moreover, the homage print of 1812 by Kiyomine duplicates this design and includes an inscription which identifies the actors and their roles (No. 91). Thus, there can be little doubt as to the date of this singularly important design. But questions still remain regarding the actual date of printing, since the large sheet includes pigment that critics believe not to be used before the time of *nishiki-e* or full-color prints (i.e., ca. 1765). As a tentative explanation, it has been suggested that this is a later reprinting by Emi-ya utilizing old blocks. If so, the value of the dated "design" is still valid as evidence of Kiyomasu's early style.[13]

Finally, there is Kiyomasu's magnificently contorted depiction of an encounter between matinee idols Koshirō (I) and Danjūrō (I) in an unidentified carriage-stopping scene. Since Danjūrō I was dead by the second month of 1704, and the two rival actors performed together in only a few plays in late 1703 and early 1704, we are on firm ground for dating this splendid design to this general period (No. 14).

Together these early prints constitute some of the finest dramatic visions in all of ukiyo-e. Their redating to an earlier time, moreover, strongly suggests that it was Kiyomasu, not Kiyonobu, who was responsible for the initial creation of this dazzling style—a style that was to influence a large percentage of all subsequent ukiyo-e. It was Kiyomasu's vitality in combination with Kiyonobu's quiet strength that was to serve ukiyo-e for generations to come.

Before closing this tribute to the genius of the early Torii masters, I would be remiss not to mention Kiyomasu's more tranquil artistic endeavors. This versatile artist was also able to emulate with equal skill Kiyonobu's more polished decorative style. In the portrait of Nakamura Gentaro by Kiyomasu, the face-type, the squat rather plump figure, and the use of the actor's *mon* as a decorative element in the composition are nearly identical with works by Torii Kiyonobu dated between 1700 and 1704. (Compare No. 15 with No. 104.) Kiyomasu goes on to develop and soften this calmer style in his own special way. For example, the master's theatrical depictions from 1715 in

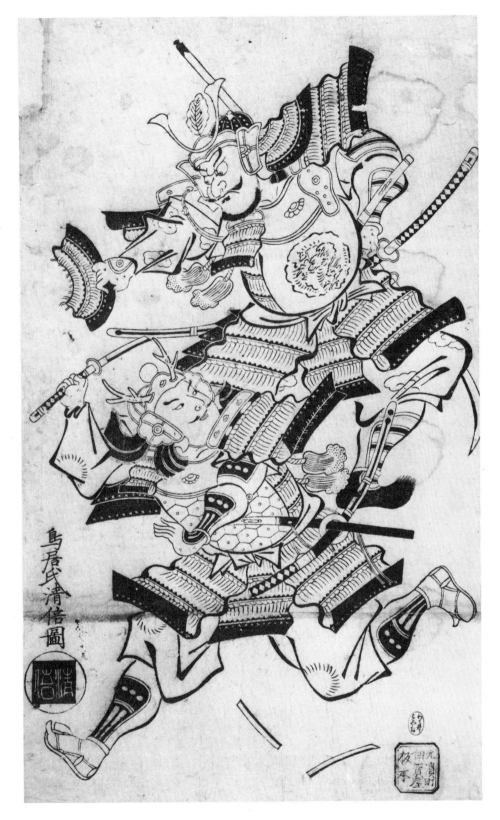

Fig. 8
WARRIORS IN COMBAT
Signature: Torii shi Kiyomasu *zu*
Seal: Kiyomasu, Publisher: Iga-ya
Date: ca. 1711
Courtesy, James A. Michener Collection,
Honolulu Academy of Arts

black-and-white album format represent a more delicate approach than anything Kiyonobu usually attempted. Yet, these excellently proportioned sheets, filled with careful detail and expertly drawn, betray the same unusual sense of figure placement as in his more powerful works (Nos. 21-24). It should be added that Kiyomasu never fully gave up his love for bold, swirling designs; a number of dramatic prints of warriors, legendary figures, and actors survive that can be dated to around 1710 and later, on the basis of either style or kabuki evidence (Fig. 8).

Perhaps the most famous of his later designs is the superb portrait of Ichikawa Danjuro II in the *shibaraku* role of Kamakura no Gongoro Kagèmasa, from the 1714 production of *Bamindaifuku chō* (No. 25). Dressed in the so-called *hattan no suho* costume of the *shibaraku* sequence and sporting the *sumi katura* hairstyle that the dynamic actor created specifically for the 1714 revival, the young Danjūrō pauses in a powerful *mie* (sustained pose), his contorted face expressing the anger of the famous theatrical incident. The vitality of the scene is captured by Kiyomasu in a spirited, yet stately, composition combining to a degree the Edo verve of his more powerful prototypes with a greater element of elegance and polish that characterized his later years.

It seems clear then that Kiyomasu and Kiyonobu represented in their initial art styles and choice of subject the division between the rough violent style of Edo kabuki and the more polished manner favored in Kamigata. In seeking clues to the identity of the shadowy Kiyomasu, and his genealogical relationship to the school's founder, Kiyonobu, such an analysis may be of value. Recent textual studies of early manuscript editions of the *Ukiyo-e Ruikō* give circumstantial support to the opinion that Kiyonobu and his family came from an entirely different branch of the Torii family than did Kiyomasu. Indeed, the only mention of the Kiyomasu name in connection with Kiyonobu's long genealogy occurs in an apparently corrupt edition of the famed biographical history; an earlier edition of the record totally omits Kiyomasu's name from the lineage.[14] We now have evidence, moreover, to suggest that an independent Torii master named Kiyotaka was probably at work in Edo at the time of Shōbei's arrival from Osaka (Fig. *9 &10*).[15] Hence, it is not difficult to speculate that two branches of the Torii were at work in Edo during the late Genroku period. Each of these branches must have perpetuated its own particular art style, based on the kabuki traditions of Kamigata and Edo, thus accounting for the early calm style of Torii Kiyonobu on one hand and the early bravura style of Torii Kiyomasu on the other.

Whatever the final answer, this much is certain: the grand design and dramatic power of these early Torii masters comes close to the very essence of art itself. It is no wonder that the vitality of these early masters was to beset so large a percentage of all subsequent ukiyo-e.

Fig. 10
COLOPHON PAGE FROM
FŪRYŪ KAGAMI GA IKE
Author: Baigin (alias Okumura Masanobu?)
Illustrator: Okumura Masanobu
Technical: *Ukiyo-zōshi,* medium-size book
Date: 1709
Courtesy, Kokugakuin University, Tokyo.

Fig. 9
TEXT PAGE WITH REFERENCE TO "TORII KIYOTAKA"
FROM *FŪRYŪ KAGAMI GA IKE*
Author: Baigin (alias Okumura Masanobu?)
Illustrator: Okumura Masanobu.
Technical: *Ukiyo-zōshi,* medium-size book
Date: 1709
Courtesy, Kokugakuin University, Tokyo.

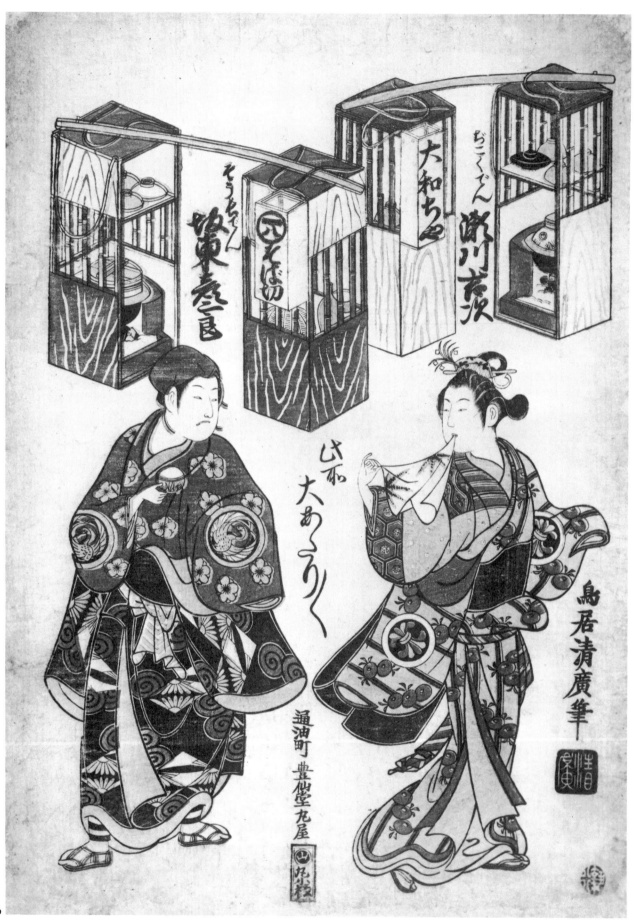

The Torii School

During the early 1700s other artists were drawn into the stylistic orbit of the early Torii masters. One edition of the *Ukiyo-e Ruikō* records Okumura Masanobu (ca. 1686-1764), Nishimura Shigenaga (ca. 1697-1756) and Kondō Kiyoharu (active 1704-1720) as pupils of Kiyonobu. The writer and antiquarian, Shikitei Samba (1775-1822), in his famous supplement adds, however, that "they were really self-taught and that all ukiyo-e at this time was done in the Torii style." Kondō Kiyoharu designed a few prints handcolored with bright orange, referred to as *tan-e*, in a style close to the Torii, but he was chiefly noted as an illustrator of *Kimpira-bon*, which as mentioned earlier, was one of the wellsprings of the bold Torii style.

It is in the early art of Okumura Masanobu (ca. 1686-1764) that we find the greatest dependence on the first Torii masters. This artist's earliest signed and dated work, an *orihon* (folding album) of courtesans which appeared in 1701, follows closely the gentle style of Torii Kiyonobu's *Keisei Ehon* of a year earlier (No. 27).[1] In 1702 and 1703 Masanobu published a few more picturebooks which were again imitative of the Torii school. Between 1704 and 1715 there appeared at least fifteen *ukiyō zōshi* (illustrated novelette) and four *rokubon* (books containing six illustrations) also done in the Torii style. A total of fourteen black-and-white albums by Masanobu have been uncovered in various states of completeness. Although none of these are dated, style considerations and comparison with the dated book art suggests they were also the product of the first fourteen years of Masanobu's artistic career. In some cases they show the strong influence of Kiyonobu and Kiyomasu (Nos. 29 & 30).

This essay has dealt thus far almost exclusively with black-and-white books, albums and large single-sheets, (the latter often colored by hand). Around 1718, as a result of the Kyōhō Reforms instituted in 1716, a major break occurred in the size and quality of ukiyo-e. The large *kakemono* format, which had served the Torii artists so well in their powerful designs, ceased to be used and the small narrow *hosoban* became the new standard. Perhaps to compensate for the size restriction, artists experimented with a wider palette of hand-painted colors, enhanced with a sprinkling of brass filings and lacquer-like coatings to strengthen the blacks. While the two names most often cited as responsible for this development, known as *urushi-e* (lacquer picture), are Okumura Masanobu and Okumura Toshinobu, it is clear that the Torii masters were quick to adopt the new medium, often producing some highly satisfying designs. In the years to come, Masanobu would claim credit for many of the technical inventions which transformed ukiyo-e from a bold decorative art to an

increasingly subtle and sophisticated art form. This included in the 1740s *hashira-e* (pillar prints) and *benizuri-e* (prints in two or three colors), the forerunner of *nishiki-e* (full-color prints). These technical inventions were very important to the generations of Torii artists to come.

The *Torii ga keifu (Kō)* notes that among the pupils at work in the Torii atelier in 1724 were Kiyotsune I, Kiyotada I, Kiyoshige, Kiyoaki, Kiyomoto II, and Kiyotomo. Of these artists, at least three made noteworthy contributions.

Torii Kiyotomo, active in the 1720s and 1730s, was probably a pupil of the first Kiyonobu. His rare work has a very special flavor of its own, distinguished by a restrained vigor and gentle mood (Nos. 54-56). Another late pupil of the first Kiyonobu was Torii Kiyoshige, active from the late 1720s to early 1760s. Beginning in the late 1720s, he designed many *yakusha-e* (actor prints) as well as *bijin-ga* (depictions of beautiful women) (Nos. 66-68). His single-sheet designs in *urushi-e* and *benizuri-e* are rather stiff and angular when compared with other artists, but his *hashira-e* are among the minor glories of the Torii school.

In this artistic milieu also moved the first Torii Kiyotada, active from 1719 to the 1750s.[3] His scant surviving output either in hand colored *tan-e* or the more luxurious *urushi-e*, seems to be a skillful fusion of the styles of Torii Kiyonobu I and the more developed style of Okumura Masanobu (Nos. 51-53). He also experimented in perspective pictures (*uki-e*) with fine results. One example, drawn from this special Torii exhibition, shows the interior of an Edo theater with a scene from *shibaraku*, acted by Danjūrō II, alias Ebizo, in a production of around 1740 (No. 53).

If the records are correct in placing the first Kiyonobu's death in 1729, then prints signed Kiyonobu after this time, must be by one or more of his numerous students. This theory finds full support in the family genealogy of the Torii school given in an early edition of the *Ukiyo-e Ruikō*, which notes a total of five artists using the Kiyonobu signature before Kiyomitsu I, the third titular head of the Torii school.[4] For convenience, all prints signed Kiyonobu dated after 1729, are catalogued by scholars as Kiyonobu II, although the problems of distinguishing the hands of the artists have yet to be resolved. The art continues to follow the basic style of Kiyonobu I, although there is generally a lack of strength when compared with the first master's powerful designs. The small *hosoban* prints of these later followers, whether handcolored *urushi-e* or the later *benizuri-e*, are nevertheless satisfying in a rather quiet way (Nos. 33-40). Inoue Kazuo, working in 1923, attempted

to equate the second Kiyonobu with Shōbei Kiyonobu's first son who died in 1752.[5] If so, prints signed Kiyonobu dated after this time must be by still another Kiyonobu artist, giving support to the opinion that a number of pupils utilized this famous name.

It is becoming increasingly clear from a study of the surviving prints that more than one artist utilized the Kiyomasu signature as well. The first, already discussed in Chapter II, was the early great master whose work in large *kakemono* size extends back in time to 1697. The second was a comparatively inept artist whose prints in a smaller format first appeared in the mid-1720s and continued until the early 1760s (Nos. 41-50). The identity of Kiyomasu II is muddled in a quagmire of conflicting and unrealiable recorded evidence with that of Kiyomasu I.[6] Just one clearly identifiable posthumous name for Kiyomasu has been discovered accompanying the birthdate 1706 on a tombstone. Since prints signed Kiyomasu are known to date before 1706, this could not refer to the first artist to use the name unless a mistake in the birthdate had occurred. Because of the second Kiyomasu's uneven print production, the few really fine examples of his art have gone unnoticed. Part of this unevenness is attributable to a certain awkwardness in the harder lines of his two-color print designs. His handcolored prints, however, are often quite fine in a subdued way, although different from the work of the first Kiyomasu. Kiyomasu II is designated as the second titular head of the Torii school and is so honored with a nine-character posthumous name. It is clear, however, that tradition has combined the two artists' achievements under the name of just one man.

Although there were many other artists at work in the Torii workshop with considerable talent, it was the second son of Kiyomasu II, Torii Kiyomitsu I, who became the third titular head of the school.[7] Born in 1735 at Naniwa-cho, Edo, he studied ukiyo-e under his father. He died in 1785 at the age of fifty-one, and was buried at Hōjōji, Asakusa, Edo. Kiyomitsu carried on the duties of producing actor prints, billboards and playbills for the Edo theaters. In these works he followed the traditional style of the Torii school. He also illustrated books from about 1764 to 1780. Most of his single-sheet prints were done during the period of *benizuri-e* (1740-1765). Toward the end of this period, however, he began to produce prints utilizing four or more printed colors, some of which may precede the full-color calendar prints of 1765. At best, he produced some remarkably satisfying designs in the Torii style. His output was great, and he had many pupils (Nos. 69-82).

At the time of the second Kiyomasu's death in 1763, the *Torii ga keifu (kō)* reports that the Torii

atelier was composed of four artists: Torii Kiyohiro, Torii Kiyoharu, Torii Kiyohide and Torii Kiyotsune II.[8] Torii Kiyohiro's work, all in two-color benizuri-e and datable to the 1750s and early 1760s, reveals a dependence on his mentor, Torii Kiyomitsu, and a contemporary, Ishikawa Toyonobu (1711-1785). His special genius was in the freshness of his compositions and the youthful character of his designing (Nos. 57-65). He was also a master of *abuna-e* (suggestive pictures) and illustrated several novelettes. In contract, is another pupil of Kiyomitsu, Kiyotsune II, whose few single-sheets, all in three-color *benizuri-e,* followed the persuasive style of Suzuki Harunobu. His numerous book illustrations are done in the Torii style (Nos. 83-90).

Among Kiyomitsu's many pupils, was one so talented that he was permitted to represent the lineage. Kiyonaga, the fourth Torii master (1752-1815), was the son of an Edo bookseller and a true giant of the nishiki-e period.[9] Although not a blood relative of Kiyomitsu, he assumed the duties of Torii IV following the death of his teacher and later abandoned his own career in order to train Kiyomitsu's infant grandson into the title, Torii V. Kiyonaga produced more than a thousand print designs, but although many of his stately portraits of courtesans and scenes of every day life tell us a great deal about the culture of the Edo merchant class, only a few deal with kabuki subject matter. These latter prints, however, reveal Kiyonaga's pioneering attempts at a more realistic portrayal of kabuki actors. This trend toward realism was to prove vital as an approach for the Katsukawa school artists and was to make possible the psychological characterizations of Tōshūsai Sharaku (active 1794-1795), Utagawa Toyokuni I (1769-1825) and Kunimasa (1773-1810).

The fifth titular head of the Torii school, Kiyomine, was the grandson of Torii Kiyomitsu.[10] He was born in 1788 at a time when the school was at its zenith. His fellow students at the atelier during this prosperous period included Kiyokatsu, Kiyotsugi, Kiyosada, Kiyotoki, Kiyohisa, Kiyofusa, and Kiyotada II. It was in 1815, upon Kiyonaga's death, that Kiyomine ascended to the title of Torii V. He designed *bijin-ga* and *yakusha-e* as well as a variety of book illustrations in his early years. Occasionally he copied the design of an earlier Torii in homage to the school's illustrious past. In such cases he would serve notice of this borrowing by utilizing a dual signature. One such print states unequivocally that the original design was by Torii Kiyonobu I, but a recent discovery has proven that the print he copied was in fact by the elusive Kiyomasu I (compare No. 13 with No. 91). No matter where one looks, one comes across more mysteries in the case of this early enigmatic print designer.

By the 1830's, the atelier added some new students including Kiyoyasu, Kiyomasa, Kiyomoto III, and Kiyotada III. According to the *Torii ga keifu (kō)*, the three kabuki theaters were moved to Asakusa in 1841. It was at this time, apparently, that Kiyomine I, the fifth Torii, changed his name to Kiyomitsu II. The succession of artists listed in family record thereafter includes mention of the sixth Torii, Kiyomitsu III and other members of the studio including Kiyotada IV, who was born in 1875.

It is an unfortunate accident of history that early collectors, particularly in the West, attuned to the grace, elegance and refinement of the full-color "brocade" print, labelled all ukiyo-e prior to the emergence of this elaborate printing in 1765 as "primitive." Few collectors saw in these grand prints their real strength and sophistication. Part of the problem, at least, rested with the lack of familiarity both in the West and in Japan with early kabuki subject matter, and the nuances of meaning intended by a particular gesture, costume design, or cryptic inscription. Until recent years this attitude has persisted, particularly with respect to the later Torii school artists. Although these neglected masters created works of superb elegance and sophistication, rarely equalled and never surpassed by subsequent artists, full appreciation of their art requires knowledge beyond an ability to distinguish fine line, color and composition. Some years ago Dr. Shibui Kiyoshi characterized ukiyo-e as "of formal simplicity of expression but complexity of overlapping nuances." This description which made specific reference to the erotic overtones of ukiyo-e is also well-suited to the art of the later Torii masters where the complexity of allusions whether erotic or not is a vital element in the final effect of the print. Two examples discussed in the catalogue illustrate this point particularly well. (See Nos. 52 and 66).

In closing, it should be noted that many specialists who have spent a lifetime studying ukiyo-e reserve a special affection for the Torii school prints. An assembly of work by these artists—Kiyonobu, Kiyomasu, Kiyoshige, Kiyotomo, Kiyotada, Kiyomitsu, Kiyonaga, Kiyohiro, and Kiyomine, to mention only a few, is positively satisfying. The work of early men like Kiyonobu and Kiyomasu, whose massive designs are patterned in a strong line and boldly colored, comes close to the essence of art itself. It is this that made possible the vital strength of Torii Kiyonaga and gave courage to the generations of Torii artists that followed in their commitment to this grand tradition.

Reference Notes

The Social and Cultural Setting

[1]Hideyori (1593-1615) was the son of the great military strategist Toyotomi Hideyoshi (1536-1598). Throughout the 16th century wars of unification were fought in Japan. Hideyoshi came from a humble background. He distinguished himself in the service of the Shōgun, Nobunaga. When Nobunaga was murdered Hideyoshi avenged him and became the most powerful man in Japan. Although his wife was barren, he had two sons by his mistress, Yodogimi. The first, Tsurumatsu, died at the age of three in 1591; the second was Hideyori. Hideyoshi was fond of this son to the point of mania. Hideyori was named Regent at the age of three in 1596. Before Hideyoshi's death in 1598, he entrusted the future of his son to a council of five elders under Tokugawa Ieyasu. Quarrels developed culminating in a civil war between the Tokugawa and Toyotomi factions—the Battle of Sekigahara (1600)—in which Ieyasu won a resounding victory. In order to smooth troubled waters, Ieyasu's granddaughter, Senhime, was given in marriage to Hideyori. This failed and in 1615 the two factions again met at the castle of Osaka which Hideyori had made his stronghold. The castle fell and Hideyori perished in the fire (others say he committed suicide) that consumed it.

[2]The time of this change is in dispute. The three ideographs, *ka* 歌 (song), *bu* 舞 (dance) and *ki* 妓 (woman), were thought to have initially been used. *Ki* carried the additional meaning of prostitute or dancing girl. Later the radical for woman in the character *ki* was cleverly replaced by the radical for person (伎).

[3]The *yakugara* system, whereby each actor specialized in one particular kind of role, is well reflected in ukiyo-e art. The courtesan would be played by a type of actor that came to be known as *waka-oyama* (young *onnagata*), while her patron was played by a *tachiyaku* (actor specializing in male roles). The master of the brothel would be a *dōke-yaku* (comic role) and the man's companion was a *yakko-gata* (servant role). In the Empō era (1673-1681), with the development of the social and historical dramas, new types of actors known as *akunin-gata* (bad man role) or *katakiyaku* (enemy role) became common.

[4]Danjūrō achievements in the development of the *aragoto* tradition were to be cut short in January of 1704. The actor, Ikushima Hanroku, enraged by the alleged mistreatment of his son, Ikushima Zenjūrō, thrust a sword through Danjūrō, ending the illustrious career of Edo kabuki's founding genius.

[5]Asai Ryōi, *Ukiyo Monogatari* ("Tales of the Floating World") (1661). The word *ukiyo* first appeared in this popular fiction. *Ukiyo* was originally a Buddhist term (憂き世) meaning "this wretched world" or "this world of misery," with an emphasis on the transitory nature of human life.

The Early Torii Masters

[1]The *Torii ga Keifu (kō)* is an unpublished manuscript of forty pages compiled in Tokyo by a person calling himself Tomosame Kaneko Masayoshi and is owned by the Torii family, Tokyo. It traces the Torii genealogy from 1645, the time of Kiyomoto's birth, down to 1875, the time when Kiyotada III died and Kiyotada IV was born. The work is, therefore, a late compilation of traditions of uncertain

reliability. Although sources for the record are not known, it is thought that the author relied heavily on the early Torii tombstones once at Somei. For many years the *Ukiyo-e Ruikō* was thought to have been compiled by Sasaya Shinshichi Kunimori, but Japanese scholars today favor the view that Shoku Sanjin, a literary man, penned the initial work around 1790. Kunimori was responsible, however, for an appendix to the work added in 1800. Santō Kyōden in 1802, and Shikitei Samba, between 1818 and 1821, added supplements, all of which were finalized into one work by the "Nameless Old Man," Keisai Eisen, in 1833. Saitō Gesshin made further additions and retitled the work *Zōho Ukiyo-e Ruikō* in 1844. Finally, in 1868, Tatsutaya Shūkin revised the entire conglomerate under the new title, *Shin Zōho Ukiyo-e Ruikō;* this work was finally printed with only minor changes in 1889 by Honma. The Nakada edition (1942) has been utilized here since it is a mosaic of manuscript editions dating from 1803 to 1889. Each edition is carefully distinguished. (See f.n. 14 for further discussion of this important manuscript.)

[2]Kiyonobu's first fully signed and dated works, two illustrated books, appeared in 1697; namely, *Honchō Nijushi Kō* signed in the colophon "*eshi* Torii Shōbei" and *Kōsho Daifuku-chō,* signed in colophon "Torii Shōbei *ga.*" Both contain art of surprisingly poor quality, revealing only occasional glimpses of the mature Torii style that other works of the same date indicate as proper for this time. (For a brief discussion of *Kōshoku Daifuku-chō,* see Shibui Kiyoshi, *Shoki Hanga,* Tokyo, 1954, p. 120. *Honchō Nijushi Kō* is reproduced in its entirety in *A Theory on the Identity of Torii Kiyomasu I,* this author's Doctoral thesis, The University of Pittsburgh, 1969.) The earliest surviving

art generally attributed to Kiyonobu is a medium-size novel (*ukiyo zōshi*) titled *Nanshoku no Someginu* (alternate Meiji title, *Iro no Someginu;* page division often reads *Iro no mai*), published in Edo in the eighth month of 1687. In one edition, possibly the first, the colophon bears the signature "*Yamato eshi* Shōbei *zu.*" The attribution is suspect, however, since the illustrations reveal nothing of the Torii style. Stylistically, *Nanshoku no Someginu* seems to be the work of an entirely different master using the Shōbei name. It should be noted that Shōbei is a personal name and while utilizing the same first character Shō that occurs in Shōshichi (the personal name of Kiyomoto), it need not refer to only Torii Shōbei Kiyonobu I. Signed copies of this illustrated book are owned by Dr. Shibui Kiyoshi and Dr. Richard Lane, both of Tokyo, Japan. Several unsigned versions survive.

[3]According to the *Torii ga Keifu kō* (c.f. footnote 1), Torii Kiyomoto had two sons and one daughter. This late record connects his name with the *kaimyō* "Ritetsu" and the dates 1645-1702, but because of a discrepancy in the dates for his wife and the fact that the original tombstones apparently did not confirm the dates, the entire identification is suspect. No extant art by Kiyomoto has been uncovered. (According to Inoue's drawings of the tombstones, the *kaimyō* was "Gentetsu" not "Ritetsu"; see f.n. 9.)

[4]The reading *Fūryū Yomo Byōbu* is based on the preface title, but *Shiho* is currently used instead of *Yomo* and may very well be as correct. Often a book set will contain different *okuri-gana* readings on the various title slips of the set's volumes. (e.g. the characters used for *Keisei Ehon* can also be read *Shōgi Gachō.*)

[5]Kiyonobu died in 1729. He received a nine-character

posthumous name, Jōgen-in Seishin Nichiryū, which was the highest status obtainable for an Edo commoner in the Nichiren Buddhist sect. His date of birth, 1664, though listed in the *Torii ga Keifu kō* and repeated on the first of two Torii tombstones, can only be accepted with caution. Likewise, the question of whether he might have been the natural or adopted son of Kiyomoto must await further research. (Link, "Speculations on the Genealogy of the Early Torii Masters," *Ukiyo-e Art,* 1972, No. 34).

⁶*Fūryū Kagami ga Ike,* 1709, penned by Baigin, with illustrations by Okumura Masanobu. Vol. II (For the original complete reading see f.n. 11) Baigin also describes the kinds of pictures that artists of the Torii and Okumura schools did and suggests that they were great rivals in 1709, the time of the novel. "It is as though they are *real* people, the first pictures of the Empress, virgins, worldly women, and low-class prostitutes." The original Japanese reads:

「今の鳥井奥村などかきさき，女むすめ娼遊女の品をかきわけて，大夫格子それより下りかたそのふうそくをうつし絵は，さりとは絵とわおもわれす，生きたる人のことくなりしを……」

Copies of *Fūryū Kagami ga Ike* are housed in the Kyoto University Library and the Kokugakuin University Library.

⁷Due to the rarity of prints signed Kiyonobu, it is Roger Keyes' opinion that designs once signed Kiyomasu, particularly those done in the bravura style, may have been "doctored" in one way or another to include a spurious Kiyonobu signature. This, he contends, accounts for the total confusion regarding Kiyonobu's primary style. Such questionable prints have been eliminated from the present discussion.

⁸Fritz Rumpf, *Meisters des Japanischen Farbenholzschnittes,* (Leipzig, 1924), pp. 17-20.

⁹Inoue Kazuo, "Torii Kiyonobu and Torii Kiyomasu" and "Generations of the Torii Line," *Ukiyo-e no Kenkyu,* July 1923, Vol. 2. Based on an intensive genealogical study of the Torii family, Inoue Kazuo concluded that there were two artists who used the name Kiyomasu and two artists who used the name Kiyonobu. According to Inoue's findings, both Kiyomasu I and II, and Kiyonobu II were sons of Torii Shōbei, or as he was also known, Kiyonobu I. Inoue's reconstruction of the artistic genealogy and his identification of the Torii family is based on the *Torii no Keifu kō* (Torii family record), one edition of the *Ukiyo-e Ruikō,* a tombstone inscription, his inability to find prints signed Kiyomasu between 1716 and 1724, and some rather artificial deductions. These deductions include: placing this hypothetical son's birth in 1696, two years after Kiyonobu's marriage; assigning all of Kiyomasu's known prints to a two-year period between 1714 and 1716; and concluding that Kiyomasu died in 1716, he connected the name with a possible *kaimyō* reading *Issan Domu* and the date 1716 appearing on Kiyonobu's tombstone.

¹⁰In 1965 it was determined to re-examine all the available evidence on the Torii school in an attempt to reach a more tenable solution than those that had been offered in the past. In 1972 the results were published in the official journal of the Japan Ukiyo-e Society (see Link, "Speculations on the Genealogy of the Early Torii Masters," *Ukiyo-e Art,* 1972, No. 34). There Kiyomasu was tentatively identified as an elder brother of Kiyonobu I, noting that until the discovery of some incontrovertible basic source directly linking Kiyomasu I with this elder

brother, that we must handle the question with caution. Scanty survival of works from this period and the demonstrated unreliability of information reported in burial and family records continue to require an attitude of unrelenting skepticism. The *Kakochō*, making reference to the elder brother of Shōbei (Shōbei Ani), has since been shown to be unreliable.

[11]A good example of the contradictions encountered follows. The *Hanna no Edo Kabuki Nendaiki* of 1811, one of our chief histories on the Ichikawa family, notes that in 1693, Danjūrō moved to Kyoto from Edo to act at the Nakamura-Uzaemon-za. Around this time he changed the written characters of his name. This name change probably signified a new level of artistic attainment and is confirmed in the 1693 illustrated book, *Kokon Shibae Hyakunin Isshu*, where the new characters are used with an illustration of the famed actor. Further, according to the *Nendaiki* he returned to Edo in Genroku 10 (1697), a statement that is repeated in Kawatake's 1935 compilation, *Kabuki Meisakushu*, and given considerable support in the colophon of the contemporaneous *eiri kyōgen bon* (kabuki picture book), *Sankai Nagoya*, dated 1697, where it notes that this performance marked Danjūrō's return from Kyoto following a four-year absence. In contrast, Ihara's *Kabuki Nempyō* and Kawatake's authoritative *Nihon Engeki Zenshi*, among others, agree that Danjūrō left Edo for Kamigata in late 1693, either the eleventh or twelfth month, but that he appeared in Kamigata kabuki only from the first month of 1694 until the ninth month of 1694, returning to Edo in time to appear in the Yamamura-za production of a Kimpira play in the eleventh month of the same year. The *Nempyō* shows Danjūrō playing regularly in Edo

thereafter. Such discrepancies are typical of this maddeningly inaccurate patchwork of documentation.

[12]A total of twenty unsigned *eiri kyōgen bon* done in the Torii style are known to survive. They are: *Sankai Nagoya* (1697), *Tsuwamono Kongen Soga* (1697), *Kantō Koroku* (1698), *Genpei Narukami Denki* (1698), *Kagemasa Ikazuchi Mondō* (1700), *Wakoku Gosui Den* (1700), *Usuyuki Ima-Chūjōhime* (1700), *Shusse Sumidagawa* (1700), *Keisei Mitsuurokogata* (1701), *Keisei Ōshōkun* (1701), *Sanze Dōjōji* (1701), *Onigajō Onna Yamairi* (1702), *Shida Kaikeizan* (1702), *Keisei Asama Soga* (1703), *Naritasan Funjin Fudō* (1703), *Oguri Jūni Dan* (1703), *Oguri Kaname Ishi* (1703), *Keisei Sumidagawa* (1704), *Yorimasa Goyō no Matsu* (1707), and *Yorimasa Mannen-Goyomi* (ca. 1704).

[13]It can be argued that these prints are all homages and hark back to earlier works by Torii Kiyonobu I which are now lost. There is a generally accepted belief that there are later pigments on some of these prints. But the only clear argument, aside from the kabuki identifications themselves, for suggesting the present datings is the crude nature of the block carving of some of these prints as well as the early quality of the paper and *tan* (red lead) pigment.

[14]The *Torii ga Keifu kō* and *Ukiyo-e Ruikō* agree on the basic ordering of the artists of the Torii school (e.g. Torii Kiyonobu, Torii Kiyomasu, Torii Kiyomitsu) completely overlooking several other artists working in the atelier. The reason for this would seem to be based on research which only recognized the titular heads, all of whom were given nine-character posthumous names. Both reconstructions overlook Kiyomoto, for example, whose *kaimyō* apparently consisted of only four-characters. (c.f. Inoue, *op cit.*) In Nakada Katsunosuke's *Ukiyo-e Ruikō*

(Iwanami, Tokyo, 1942, pp. 56-57), however, the following family genealogy is listed under the superscript for Saito (増) 1) Kiyonobu 2) Kiyomasu 3) Kiyonobu 4) Kiyomasu 5) Kiyonobu III 6) Kiyomitsu 7) Kiyonaga. The source of the statement was apparently Saito Gesshen's *Zohō Ukiyo-e Ruikō* of the 1840s and 1850s. In any event, the statement suggests that there were two artists utilizing the art name Kiyomasu and three artists utilizing the art name Kiyonobu. It also includes the statement: "Kiyonobu: elder brother passed away early, younger brother passed away early." Thus, the confusion surrounding the Torii school is in part the result of the inclusion of two kinds of lineages—first an artistic pedigree which lists five generations of Torii painters from Kiyonobu to Kiyomine and second, a family genealogy. In contradiction to the family genealogy, indicated above, Mr. Kitakoji has uncovered an early manuscript edition which lists a total of five artists utilizing the Kiyonobu name before Kiyomitsu, who was the sixth generation Torii according to his reckoning, two of whom died young. It is thought that the Saitō edition corrupted this original family listing to include the names of Kiyomasu I and II. The absence of the Kiyomasu name in the genealogy, uncovered by Mr. Kitakoji, suggests that the five Kiyonobu artists noted were blood relations and that the two Kiyomasu artists were unrelated to this direct family lineage. In other words, the enigmatic Kiyomasu may have been from an entirely different branch of the Torii family than Kiyonobu, connected only to the artistic pedigree of kabuki billboard painters.

[15]Torii Kiyotaka's name occurs in the *Koga Bikō*, but his existence has never been confirmed by any surviving art. The 1709 edition of *Fūryū Kagami ga Ike*, however, indicates that Torii Kiyotaka was the veteran artist of the Torii school and the teacher of Shōbei. His dates of birth and death are unknown, as well as his genealogical relationship to the other members of the Torii school. The use of the term *rohitsu* (veteran) in the text reference may suggest that he was considerably older than the other members of the Torii family and as such the true founder of the Torii school. This contemporary reference then opens up an entirely new line of investigation. Moreover, postulating a Torii artist before Kiyomoto (the Kamigata actor/artist and father of Kiyonobu) might help explain the family's move to Edo from Kamigata, their interest in kabuki art after their arrival and the emergence of a fully-developed style of Torii art with no apparent antecedents. The passage dealing with the artist Torii Kiyotaka occurs in Vol. II of *Fūryū Kagami ga Ike*. It reads: "Particularly among them (the artists of the day) is the veteran (*rohitsu*), Torii Kiyotaka, who has a delicate, indeed elegant and very tasteful style of art. He is not copied easily by others; the style of his pupil, Shōbei, altered this elegant mood and drew pictures of women in modern hair styles, including the special hair style, *nage shimada*. The style and the pictures became very popular for the pictures served as hair dressing models." During this period also, when admiration for the stars of the kabuki stage had reached a point that was almost idolatry, many pictures of actors were placed in shrines as a sort of substitute for the votive horse picture. Baigin relates that "Shōbei's style was well suited to kabuki and that his actor pictures were to be seen in all the shrines." One picture was so skillfully drawn that Baigin tells us: "Shōbei captured the character's emotions perfectly. Everyone who visited the shrine," Baigin declared

enthusiastically, "was impressed by the picture and crowds were always to be seen standing around in admiration." The actor depicted was Nakamura Gentarō in the role of Murasaki-ya Ogen, who was in love with Master Shichi. The original reads:

「わきて鳥居清高は老筆のめつらかにも風流なりし秘伝の筆，
その門弟ニ庄兵衛こまかやなりしきをかへてなけ嶋田をかき
だして，絵よりもまなふをんなのふう，これ名人の名とり川
にくらしからぬ筆ゆへに近代芝居のすかたえはどこの絵馬の
間にもあるか中にもあるやしろに，中村源太郎かむらさきや
小源になりしおもかけは，恋させ給ふ七殿ニうらみの数をふ
くみける。そのおもさしを書たりしは近代まれなる出来
嶋絵と，皆立とまる色絵とこそうけたまわり候なり」

The Torii School

[1]A number of related albums done in the persuasive style of Torii Kiyonobu's *Keisei Ehon (Shōgi Gachō)* are relevant. Kiyonobu's book apparently proved so popular that a few months after its initial appearance, in the sixth month of 1701, the publisher, Kurihara Chōemon, produced a re-engraved copy (possibly utilizing the *kabusebori* technique) under the title, *Meigi Jūhachi Koō*. This plagiarized eighteen-page edition was later renamed *Shōgi Gachō*. Two months later in the eighth month of 1701, Kurihara Chōemon published the book of courtesans designed by Okumura Masanobu being considered here. The designs bear a striking resemblance in style to Kiyonobu's original work, but only one design in Masanobu's version, depicting a hair combing sequence, seems to be a direct borrowing. Moreover, none of Masanobu's courtesans' names bear any relationship to those found in Kiyonobu's book. In the first month of 1702, however, another publisher, Kodera Chōbei, produced a courtesan book containing a larger number of pages by Masanobu, several of which relate to Kiyonobu's *Keisei Ehon*. Other pages offer entirely different compositions. Although no complete titled copy of this album is known, several pages from the work (formerly part of the Frank Lloyd Wright Collection) are now in the Pasadena Art Museum. It is also reported that a twenty-two page album of courtesans was published under the title, *Keisei Zu*, in the eighth month of 1711. This work apparently copies Kiyonobu's famous book of 1700. Yoshida reports that the colophon of this work bears the name of Okumura Masanobu and the publisher, Takeda Chōemon.

[2]The source of this tradition would appear to be supposition based upon the *Torii ga Keifu kō* entry noted above. There has been no attempt by modern scholarship to locate his posthumous name in burial record.

[3]Torii Kiyotada's biography is unknown.

[4]See f.n. 14, Chapter II.

[5]Inoue, *op cit.* Kazuo Inoue identifies Kiyonobu II as the third or fourth son of Kiyonobu I and the common name Teishirō, later Shōbei. He equates this son, noted in the *Torii ga Keifu kō* with the posthumous name, *Chiryū-in Hogen*, and the death date 1752.

[6]Inoue, *ibid.* Kiyomasu II is identified by Inoue as an adopted *muko* (son-in-law marrying into his wife's family) of Kiyonobu I. He married Kiyonobu's eldest daughter in 1724. His personal name is uncertain although Inoue tentatively identifies it as Hansaburō. His posthumous name, consisting of nine-characters including the honorific, suggests that he had achieved the same high

status as Kiyonobu in the Nichiren sect. His *kaimyō* reads: Seigon-in Sārin Nichijō. This posthumous name appeared on a second Torii tombstone (distinct from that reserved for Kiyonobu and his direct lineage) with his date of birth and death (1706-1763).

[7]Kiyomitsu I's personal name was Kamejiro. Upon his death he received a posthumous name composed of nine-characters including the honorific. Such designations seem to be reserved for the titular heads of the school.

[8]The name Torii Kiyoharu has been so confused with that of Kondo Kiyoharu and Ryūsōshi Kiyoharu that some art historians have sought to identify all three as one and the same master. The three artists flourished from around 1700 to 1730, judging from their scant surviving art. The *Torii ga Keifu kō* may be making reference to a later artist who apparently used the same name since the entry cites a period in the 1760s. Torii Kiyohide was probably the son of Kiyomitsu I. He died while still very young in 1772 according to Inoue (*Ukiyo-e no Kenkyū*, nos. 7 and 8, p. 26). Although no broadsheets are known to survive, several illustrated *aohon* (blue book) are known and a signed *tsuji banzuke* (playbill) of a play performed at the Morita-za in 1771. Kiyohiro's personal name is given in record as Shichinosuke. The *Ukiyo-e Ruikō* says he resided in Sakai-machi.

[9]Kiyonaga's biography is based on a patchwork of incomplete and often conflicting records. The fullest account occurs in the *Ukiyo-e Ruikō* which indicates his family name as Seki, his given name as Ichibei (or Shinsuke according to another source quoted). His father, Shirokiya Ichibei, was a book dealer and superintendent of tenement houses owned by Teramoto, a tobacconist, at Shimba. His family name is now generally given as Sekiguchi, based on the use of a seal with that reading occurring in his illustrated book *Ehon Monomigaoka*. This opinion is also repeated in *Torii ga Keifu (kō)*. *Aohon Nempyō* explains that Kiyonaga was first called Shinosuke and that later he changed it to Ichibei. In seeming contradiction to the *Ukiyo-e Ruikō* noted above, the tradition of the Torii family as set down in the *Gekiga Shū*, edited by Banu Kaneko, suggests that Kiyonaga came from Unaga, Sagami Province, and was the son of Awaya Jinemon. If so, he must have come up to Edo before 1767, for a work survives signed by the young master dated to this time. His tombstone has never been positively located.

[10]Kiyomine's real name was Shōnosuke. Along with the art names Kiyomine and Kiyomitsu II, he also used the *gō* (alternate name) Seiryūken.

CATALOGUE

Catalogue Notes

In 1970, the author noted in his study of the Torii school that "much research remains to be done before the record of the Torii family can be written down as factual history." The present catalogue, within the limits of what could be loaned for exhibition, attempts to deal with some of the more significant Torii works that "document" portions of this history. It is hoped that the presentation of this material will encourage a fresh look at what this writer believes to be important material to the study of these artists. A few notes on the organization of the catalogue follows.

Artists are ordered according to their working periods or their dates of birth and death. Each artist's work is arranged chronologically, allowing for ease in reference and in explaining the development of his art. Unsigned prints, whether universally attributed to an artist or not, have been grouped separately and arranged chronologically within the division.

Exact dates are used when the evidence warrants. Theatrical prints are dated to opening performances of plays where possible and followed by the name of the performance and the theater. Exact dates are given when known. Other dates are based on style and inference. Dates follow the old Japanese lunar calendar.

The exact measurement of each full sheet is given in centimeters with height preceding width. The traditional terms for size (i.e., *hosoban, oban,* etc.) have been retained.

The traditional categories for describing prints by the colors used in them (*urushi-e, benizuri-e,* etc.), however, seem too unwieldy and imprecise and have not been utilized. Instead, descriptive phrases (hand-colored *hosoban;* two-color *hosoban* in pink and green (e.g. benizuri-e) etc.) have been preferred.

The subentry for signature and seals refers to the transcription of the designer's art name and seal and not that of the engraver or printer who actually executed the work. Where a print is unsigned or does not bear an artist's seal, these facts are noted.

Wherever possible the name of the publisher responsible for the overall production of the print is included. Where the print lacks a publisher's seal, the subentry is omitted.

Comments on condition, former owners, and publication of the same impression have been deleted here since such information, in our opinion, is better considered in the official catalogue of the collection from which the print comes.

Finally, the text for each print attempts only briefly to define the subject of the design, describe differing states of the same subject, and, occasionally, justify the reason for the date, identification, or attribution when it might seem controversial.

6 KIYONOBU I

Title: FUJIMURA HANDAYŪ II
Date: late 1710s
Technical: handcolored *hosoban*, 34 × 16 cm.
Signature: Torii Kiyonobu *hitsu*
Publisher: Hammoto Moto-hama-chō Iga-*ya*
James A. Michener Collection, Honolulu Academy of Arts

The *onnagata*, Fujimura Handayū, appears in possibly a mad scene from an unidentified play presented in the late 1710s. Neither the date nor the role offered in Michener (No. 24) can be reconciled with the somewhat later style and iconography of the print.

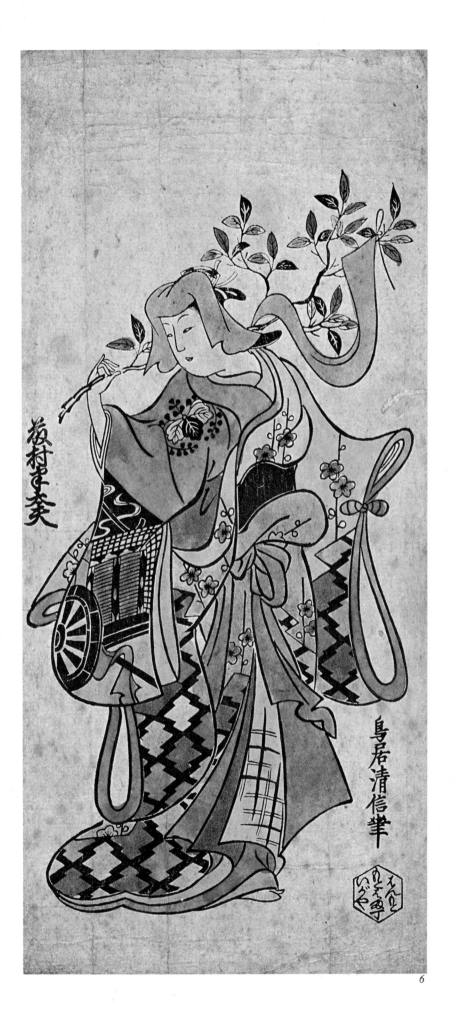

13 KIYOMASU I

Title: ICHIKAWA DANJŪRŌ I AS YAMAGAMI SAEMON AND
YAMANAKA HEIKURŌ AS SUZUKA NO ŌJI
Date: 1701, first month
Technical: handcolored *kakemono-e* 59.1 × 32.4 cm.
Signature and Seal: Torii Kiyomasu *zu*, Kiyomasu
Publisher: Emi-*ya*
Nelson Atkins Gallery, Kansas City, Missouri
Note: United States showings only

Ichikawa Danjūrō I as Yamagami Saemon and Yamanaka Heikurō as Suzuki no Ōji are shown
in the act of ripping apart an elephant from the play, *Keisei Ōshōkun*, produced at the
Nakamura-za in 1701. This print was brought to the author's attention by Mr. Suzuki Jūzō and
Mr. Roger Keyes in 1971. Mr. Suzuki tentatively dates the print to the 1701 production of *Keisei
Ōshōkun*. Since all the available sources, including the *Kabuki Nempyō*, only record the 1701
performance, the identification seems likely. Along with these records, the original *eiri
kyōgen-bon* for the 1701 play has been located, and although the book does not illustrate our
scene, the plot summary leaves little doubt that the assignment is correct. (For the Kiyomitsu
II's homage print of the same subject, see No. 91.)

25 KIYOMASU I

Title: ICHIKAWA DANJŪRŌ II IN A SHIBARAKU ROLE
Date: 1714, eleventh month
Technical: handcolored *kakemono-e*, 59.4 × 31.7 cm.
Signature and Seals: Torii Kiyomasu, Kiyomasu
Publisher: Shimmei-mae Emi-*ya* Yoko-chō
Additional Seal: Ōta (lower left at top), Nampo bunko (lower left
at bottom). Ōta Nampo (1749-1823), a literary man,
was an historian of ukiyo-e and at one time owned
this print.
*Hiraki Collection, Riccar Art Museum; Registered Important Cultural
Property*

Although the *shibaraku* (literally, "Wait a minute!") sequence was invented by the first Danjūrō,
the advanced costume and make-up of this illustration suggests that this is Danjūrō II in one of
the revivals, perhaps the 1714 Nakamura-za production of *Bamindaifuku chō*. In this production
he dressed in the so-called *hattan no suho* (large-sleeved) costume and wore the *sumi katura*
hairstyle specifically created for the 1714 revival. It is interesting to note that the publisher,
Emi-ya, has departed from the use of cinnabar red and has painted Danjūrō's costume
purple—a color commonly not seen until around the time of three-color printing (i.e., 1760).
The color could have been added later, of course, but it is also possible that this print was
republished by Emi-ya at a much later date.

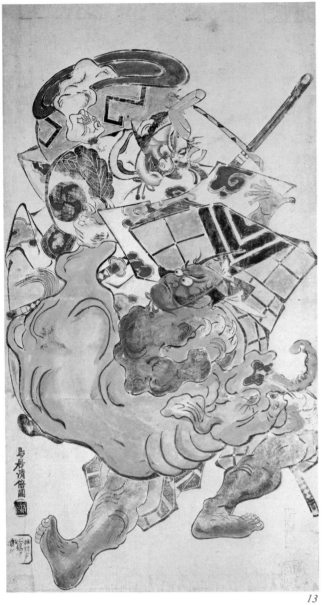

13

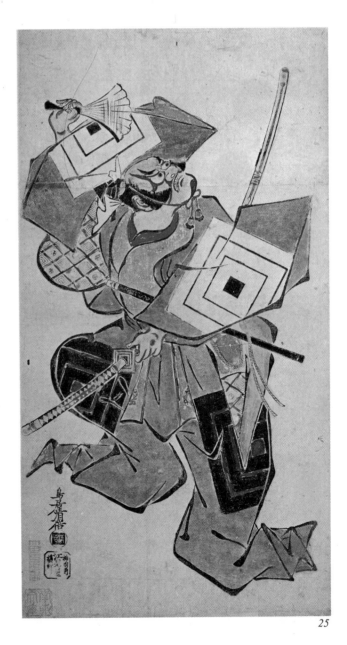

105 UNSIGNED

Title: YAMANAKA HEIKURŌ AS TAIRA NO KIYOMORI AND
SUZUKI HEIKICHI AS NAKATSUMA
Date: 1707, first month
Technical: handcolored *hosoban,* 31.5 × 14.8 cm.
Publisher: Hangi-*ya* Shinsuke *han*
Hiraki Collection, Riccar Art Museum; Important Art Object

In this splendid small print can be observed the combination of two distinct Torii styles; the
bombastic vigor of Yamanaka Heikurō, that master of villainous roles, is in sharp contrast to the
soft cursive rendering of the *onnagata,* Suzuki Heikichi. Yet, the overall decorative quality of the
total design is maintained and the powerful Torii formulas associated with *aragoto* roles is only
faintly suggested. These qualities are typical of the art of Torii Kiyonobu I, to whom this print is
traditionally attributed. The print has been reasonably identified with the Yamamura-za stage
production of *Yorimasa Goyō no Matsu* presented in 1707, in which both actors appeared in the
roles noted above. Both actors in the print are identified by *mon* and inscription.

59 KIYOHIRO

Title: BANDŌ HIKOSABURŌ II AS SŌCHŌDEN AND
SEGAWA KICHIJI II AS JIKOKUDEN
Date: 1753, eleventh month
Technical: two-color *ōban,* 42.5 × 30.2 cm.
Signature: Torii Kiyohiro *hitsu*
Publisher: Tōri-abura-chō Hōsendō Maruya (with seal)
James A. Michener Collection, Honolulu Academy of Arts

Bandō Hikosaburō II (left) appears as Sōchōden and Segawa Kichiji II as Jikokuden, both
identified by inscription, in the dance, "Akutagawa Momiji no Shiragami," from the 1753
Ichimura-za production of *Kammuri Kurabe Yawarage Kuronushi.* The key block of this print was
reused in the eleventh month of 1755 with extensive alterations.

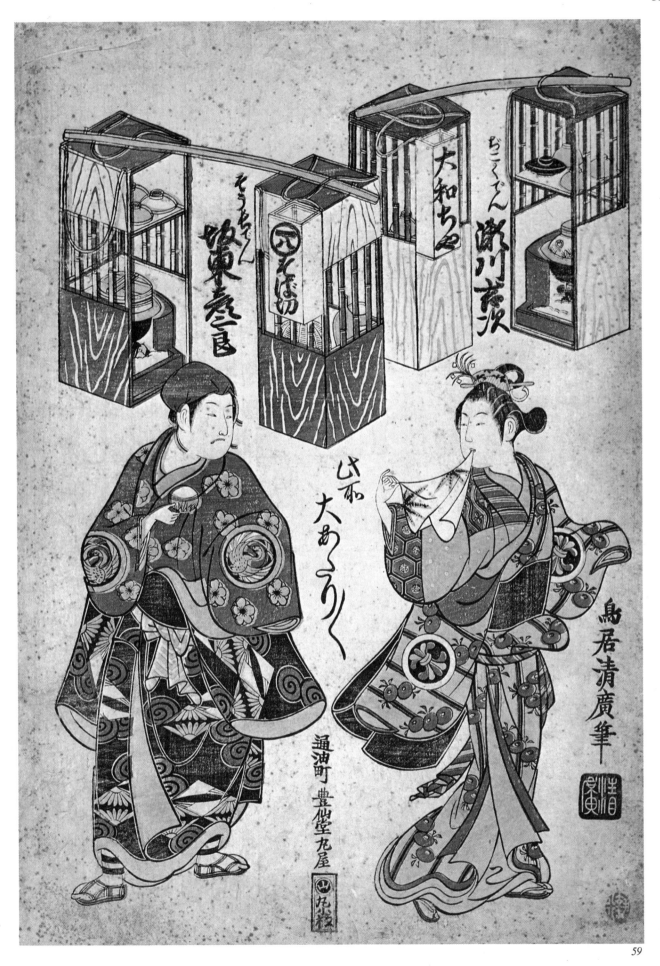

1 MORONOBU (d. 1694; active from early 1670s)

Title: CHŪIRI KASHIRAZU BUKE HYAKUNIN ISSHU
(ONE-HUNDRED POEMS BY WARRIORS, WITH
COMMENTARIES AND ILLUSTRATIONS)
Date: Kambun jūni mizunoe ne toshi mōshun kichijitsu
(An auspicious day in the New Year Season of 1672)
Technical: black and white book complete in one volume,
47 folio pages and colophon with original
blue covers and title slip, 26.5 × 18.5 cm.
Signature: Eshi Hishikawa Kichibei
Publisher: (Tsuru)-ya Kiemon *han*
Calligrapher: Hissha, Tōgetsu Nanshu
James A. Michener Collection, Honolulu Academy of Arts

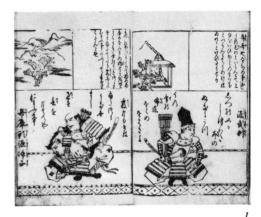

1

This double-page illustration from a late edition of the book *(Chūiri Kashirazu) Buke Hyakunin Isshu,* first published in 1672, is based on the traditional *Hyakunin Isshu (One-hundred Poems by One-hundred Poets)* but refashioned for a book on great samurai poet figures of the past. The work is the earliest known signed and dated work of Hishikawa Moronobu.

2 KIYONOBU I (ca. 1664-1729)

Title: SAWAMURA KODENJI AS TSUYU NO MAE
Date: 1698, third month
Technical: handcolored *kakemono-e,* 53 × 30.8 cm.
Signature and Seal: Wagakō Torii Shōbei, Kiyonobu
Publisher: Hangi-ya *hammoto*
John Chandler Bancroft Collection, Worcester Art Museum, Massachusetts.

This print has been identified as the *onnagata* Sawamura Kodenji in the role of Tsuyu no Mae performing a *kyōran* (lunatic dance) before Tadasu Shrine in the 1698 Nakamura-za production of *Kantō Koroku.* The identification is confirmed by the discovery of the *eiri kyōgen-bon* of the performance with a variant illustration of the same scene (see No. 98f). This impression appears to be the only complete version extant. Other *kakemono* impressions are "reconstructed" from the beginning of the signature where the two sheets of paper are joined, on down.

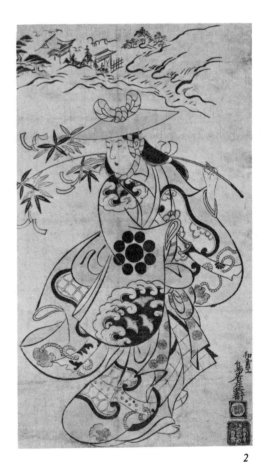

2

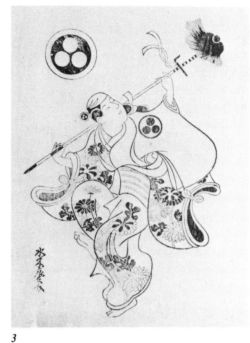

3

3 KIYONOBU I (ca. 1664-1729)

Title: FŪRYŪ YOMO BYŌBU (FASHIONABLE SCREENS OF THE FOUR DIRECTIONS)
Date: "An auspicious day of the third month of Genroku 13" (1700)
Technical: Pages mounted separately from an illustrated book, in one volume originally containing 43 illustrations, each measuring 27 × 18.5 cm. Illustrations mounted separately, vary in dimension slightly.
Signature and Seal: Wagakō Torii Shōbei Kiyonobu; Kiyonobu (at end of
Publisher: Izumi-chō Hangi-*ya* Shichirobei han (on last page)
Hiraki Collection, Riccar Art Museum; Important Art Object

The mature style of Torii Kiyonobu I is in evidence in this superb book of actors. Although the Torii conventions used for *aragoto* subjects (e.g., the *hyōtan ashi* and *mimizu gaki* characteristics) can be observed in many of the actor portraits, the prevailing tendency is toward a full decorative treatment. Kiyonobu's *aragoto* depictions lack the explosive quality observed in the art of his contemporary, Kiyomasu I.

4

4 KIYONOBU I

Title: COURTESAN PAINTING A SCREEN
Date: 1711, eighth month
Technical: black and white *ōban,* 27 × 36.6 cm.
Signature and Seal: Kiyonobu, Kiyonobu (both appearing on the screen)
Publisher: Takeda Chōemon Yokoyama Dobō-chō
Hiraki Collection, Riccar Art Museum

The Hiraki Collection owns both the first leaf (shown here) and the last leaf which includes a printed inscription naming the publisher and date of publication (see No. 5). These prints are identified by Shibui Kiyoshi as Series B and collated with a set of twelve erotic prints. The work is typical of the first Kiyonobu's early mature style.

5 KIYONOBU I

Title: READING A BOOK
Date: 1711, eighth month
Technical: black and white ōban, 27.5 × 39.2 cm.
Signature: Unsigned
Publisher: Takeda Chōemon
Hiraki Collection, Riccar Art Museum

From a set of twelve erotic prints, the first of which is signed and sealed Kiyonobu, this dated leaf appears to be the last sheet from the set. The inscription reads: "Takeda Chōemon, Yokoyama Dobō-chō, Shōtoku 1, eighth month (1711)." This bold design with flowing line and emphasis on the volume of the figures is typical of Kiyonobu's fully-developed curvilinear style.

5

7 KIYONOBU I

Title: ICHIKAWA KUZŌ IN THE ROLE OF MIURA ARAJIRŌ
Date: 1718, eleventh month
Technical: handcolored hosoban, 29.5 × 15.8 cm.
Signature: Torii Kiyonobu *hitsu*
Publisher: Shimmei-mae yoko-chō Emi-*ya*
James A. Michener Collection, Honolulu Academy of Arts

Ichikawa Kuzō, identified by inscription to the left, appears in the role of Miura Arajiro in the kabuki drama, *Zen kunen yoroi kurabe,* performed at the Morita-za in the eleventh month of 1718.

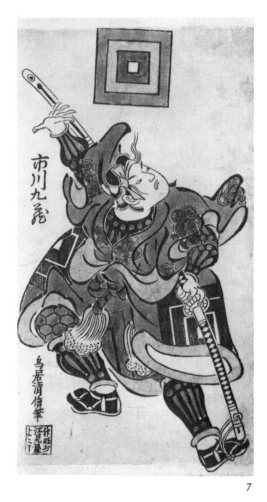

7

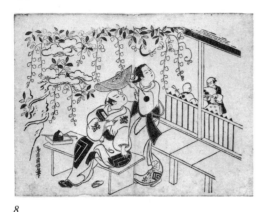

8

8 KIYONOBU I

Title: ICHIKAWA DANJŪRŌ II AS HIRANOYA TOKUBEI AND
SANOGAWA MANGIKU AS TEMMAYA OHATSU
Date: 1719, first month
Technical: black and white horizontal *aiban* sheet, 29.8 × 21.7 cm.
Signature: Torii Kiyonobu *hitsu*
Publisher: No mark
James A. Michener Collection, Honolulu Academy of Arts

Ichikawa Danjūrō II in the role of Hiranoya Tokubei (seated) and the *onnagata*, Sanogawa
Mangiku, as Temmaya Ohatsu are shown in the 1719 Nakamura-za production of *Sogazaki
Shinju*, a play based on the earlier *Sonezaki Shinju* of Chikamatsu.

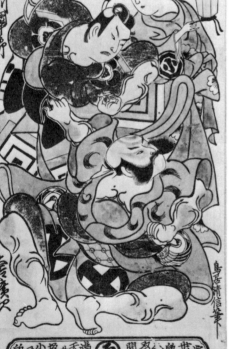

9

9 KIYONOBU I

Title: THE ACTORS, ICHIKAWA DANJŪRŌ II, ŌTANI HIROJI
AND ARASHI WAKANO
Date: ca. early 1720s
Technical: handcolored *hosoban*,· 34.3 × 16.4 cm.
Signature: Torii Kiyonobu *hitsu*
Publisher: Komatsu-*ya* (cartouche reads: Ukiyo-e hammoto
Ezōshi Donya Yushima Tenjin Onnazaka-shita
Komatsu-ya hammoto; published by Komatsu-*ya*
wholesaler of illustrated books and printer of
ukiyo-e, Yushima Tenjin Shrine at the foot of Onnazaka)
Hiraki Collection, Riccar Art Museum; Important Art Object.

The actors, Ichikawa Danjūrō II, Ōtani Hiroji and Arashi Wakano, identified by inscription and
actors' *mon* (family crest) are depicted in a *Kusazuri biki* sequence (pulling of armor) from an
unidentified Soga play probably performed in the early 1720s. Ichikawa Danjūrō II, in the role
of the impetuous Gorō, is being held back from angerly attacking the villain Kudō by his
trusted servant Asahina (Ōtani Hiroji). The courtesan Shōshō (Arashi Wakano) completes the
famous *mie*.

One of the earliest surviving illustrations depicting this sequence occurs in the *eiri
kyōgen-bon* of 1697 celebrating the Nakamura-za production of *Tsuwamono Kongen Soga* (see No.
97, k and l). This print is dated on the basis of style, the acting periods of the three actors
shown and technical aspects of the impression itself. This last factor is of particular interest
since the work has been handcolored with a combination of cinnabar, used in early colored
prints, and rose, which was introduced later, suggesting that this is a transitional print.
Stylistically, the design follows the Torii formula and is probably the work of the first Kiyonobu.
(For a print inspired by the same theatrical sequence, see No. 114).

10 KIYONOBU I

Title: YORITOMO'S HUNT AT THE FOOT OF MT. FUJI
Date: ca. 1720
Technical: handcolored horizontal *kakemono-e,* 52 × 29.8 cm.
Signature: Torii Kiyonobu *hitsu*
Publisher: No mark
James A. Michener Collection, Honolulu Academy of Arts

10

This large horizontal print is divided into two main episodes: Yoritomo by Mr. Fuji and Soga Gorō sharpening his arrow during a boar hunt. The scenes possibly record a Soga play produced in 1720 at the Nakamura-za.

11 KIYONOBU I

Title: FUJIMURA HANDAYŪ II AS KIKUSUI
Date: 1727, eleventh month
Technical: handcolored *hosoban,* 34.6 × 16 cm.
Signature: Torii Kiyonobu *hitsu*
Publisher: Komatsu-*ya*
James A. Michener Collection, Honolulu Academy of Arts

The *onnagata,* Fujimura Handayū II, in the role of Kusunoki's wife Kikusui is disguised as a vendor of bamboo articles. It is sometimes difficult to distinguish the prints made in the 1720s by Kiyonobu I from those produced by Kiyonobu II. This design may be the late work of Kiyonobu I, since it is clearly related in style to the Michener Collection's print of Fujimura Handayū (No. 6) and is more skillfully accomplished than Kiyonobu II's prints of a slightly later date.

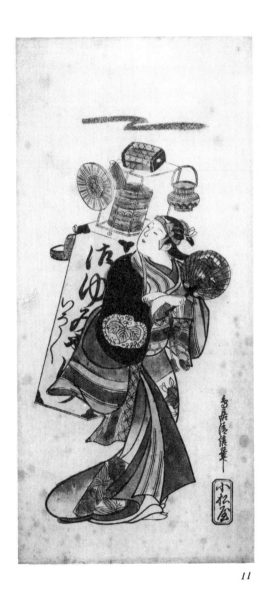

11

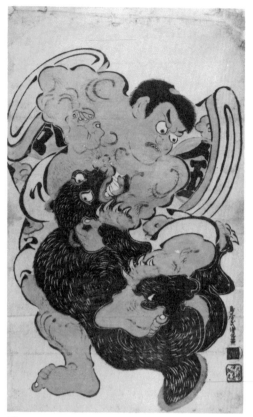

12

12 KIYOMASU I (active mid-1690s to early 1720s)

Title: KINTOKI WRESTLING WITH A BLACK BEAR
Date: ca. 1700
Technical: handcolored *kakemono-e*, 55.1 × 31.9 cm.
Signature and Seal: Torii *Uji* Kiyomasu *zu*, Kiyomasu
Publisher: Moto-hama-chō Iga-*ya hammoto*
James A. Michener Collection, Honolulu Academy of Arts

Kintoki, the legendary Hercules figure of Japan, is seen wrestling with a black bear. His swirling garments include the identifying character *kin*, partly colored in yellow. This powerful design, one of the finest Torii style prints in existence and the only recorded impression, can be dated on the basis of style, signature, technical matters and the use of vivid *tan* to around 1700. The work is stylistically comparable to the often illustrated "Danjūrō as Gorō Uprooting a Bamboo", by the same artist and publisher, and at least two other prints all dated by kabuki evidence from 1697 to 1704.

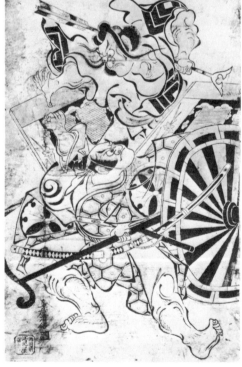

14

14 KIYOMASU I

Title: KOSHIRŌ I AND DANJŪRŌ I
Date: ca. 1703-1704
Technical: handcolored *kakemono-e*, dimensions not available at press time
Signature and Seal: Torii Kiyomasu, Kiyomasu
Publisher: Emi-*ya*
Werner Schindler Collection, Switzerland

Since Koshirō I and Danjūrō I were rivals, one is limited to just a few plays in which they appeared together. According to the *Hana no Edo Kabuki Nendaiki*, the two actors starred together in the *kaomise* (face-showing) production, *Genji Rokujū Jō*, given in the eleventh month of 1703. During this performance there was a big fire in Edo, and both the Nakamura-za and the Ichimura-za (the theater which presented the Genji play) were totally destroyed. Apparently a temporary stage was built so that kabuki could continue, for the *Kabuki Nempyō* reports that on the 10th of November, 1703, a new play entitled *Shinoda-zuma* (alternate title: *Ashiya Dōman*) was presented. In the second month of 1704, the Ichimura-za gave the play, *Hoshiai Jūnidan*, with the great Danjūrō I in the role of Satō Tadanobu. This turned out to be Danjūrō's last public performance, for his life was cut short at the age of 45 years. It has been cautiously suggested that the scene may refer to the famous "carriage-stopping" scene between Gorō and Asahina in Kudō's courtyard. According to the *Kabuki Nempyō* (Vol. I, p. 314), two Soga plays were performed at the Ichimura-za in the first month of 1704, although no confirmation can be found in the *Hana no Edo Kabuki Nendaiki* or Ihara's *Nihon Engekishi*. Confirmation from kabuki scholars with access to more contemporary documentation (e.g., *banzuke, eiri-kyōgen-bon*, etc.) is needed before this identification can be fully accepted.

15 KIYOMASU I

Title: NAKAMURA GENTARŌ AS AYAME (?)
Date: ca.1705
Technical: handcolored *kakemono-e*, 55 × 33 cm.
Signature and Seal: Torii Kiyomasu, Kiyomasu
Publisher: Sakai-chō Nakajima-*ya hammoto*
Watanabe Collection, Tokyo

Nakamura Gentarō appears in an unidentified play probably produced in the early 1700s. On stylistic grounds, this signed *kakemono-e* is believed to be an early work. The face type, the squat, rather plump figure and the use of the actor's *mon* as a decorative element in the composition are nearly identical with works by Torii Kiyonobu dated between 1700 and 1704 and offer proof that Kiyomasu worked in the same early style as Kiyonobu (compare this design with those appearing in *Fūryū Yomo Byōbu*, No. 3). Yoshida identified the role as Ayame because of the iris pattern appearing on the *onnagata's* robe. The identification is therefore quite tentative. This impression appears to be the only one that survives.

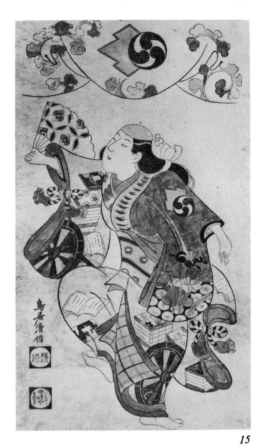

15

16 KIYOMASU I

Title: KONORI TAKA (SPARROW HAWK)
Date: ca. 1715
Technical: handcolored *kakemono-e*, 55 × 28.6 cm.
Signature and Seal: Torii Kiyomasu, Kiyomasu
Publisher: No mark
Clarence Buckingham Collection, Art Institute of Chicago

Identified in the circular cartouche as a sparrow hawk, this large dramatic print is one of a group signed or attributed to the first Kiyomasu but based on a 1687 book of falcons and falconry entitled *Nigiri Kobushi (The Clenched Fist)*. Some of the prints are such close copies that earlier critics attributed this book unreasonably to Kiyomasu I. The book is now thought to be by an unknown artist of the traditional Kanō school and the source of inspiration for the Kiyomasu single-sheets. The date offered above is a traditional one and is not supported by any evidence.

16

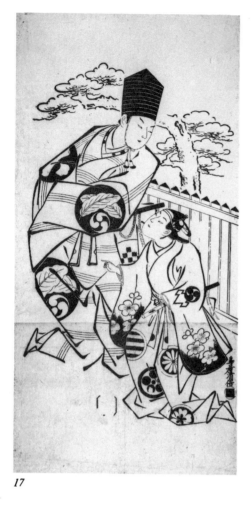

17

17 KIYOMASU I

Title: YAMANAKA HEIKURŌ AND NAKAMURA TAKESABURŌ
Date: early 1710s
Technical: black and white *kakemono-e*, 65.2 × 32.5 cm.
Signature and Seals: Torii Kiyomasu, Kiyomasu
Publisher: name removed from block
James A. Michener Collection, Honolulu Academy of Arts

The actors, Yamanaka Heikurō (left) and Nakamura Takesaburō, in a scene from an unidentified play presented around the 1710s, are identified by their theatrical *mon*. This print's identification with the Ichimura-za performance of *Yoroikurabe Ōshū no Kogane* during the eleventh month of 1716 cannot be confirmed.

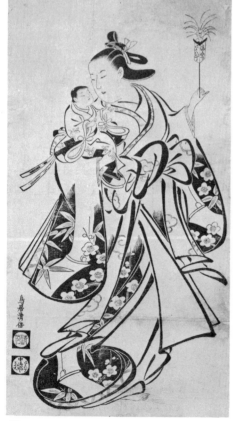

18

18 KIYOMASU I

Title: WOMAN WITH TOY LANTERN CARRYING A CHILD
Date: ca. 1715
Technical: black and white *kakemono-e*, 57.1 × 31.1 cm.
Signature and Seal: Torii Kiyomasu; Kiyomasu
Publisher: Sakai-chō Nakajima-*ya hammoto*
Clarence Buckingham Collection, Art Institute of Chicago

The virtuosity of Kiyomasu's calligraphic line and the bold delineation of the courtesan's robes become almost an abstraction in this fine composition. The writing on the small toy lantern reads: "O Matsuri Sakai-chō" (The Festival of Sakai Street).

19 KIYOMASU I

Title: THE ACTORS, ICHIKAWA MONNOSUKE I AND
TAMAZAWA RINYA
Date: ca. 1715
Technical: handcolored *kakemono-e*, 55.9 × 31.5 cm.
Signature and Seal: Torii Kiyomasu; Kiyomasu
Publisher: Motohama-chō Iga-*ya hammoto*
Clarence Buckingham Collection, Art Institute of Chicago

The actors, Ichikawa Monnosuke I and Tamazawa Rinya have been identified as Kamo no Jirō
and Shirate in the drama, *Zen Kunen Yoroi Kurobe*, performed at the Morita-za in the eleventh
month of 1718. According to the *Kabuki Nempyō* (Vol. I, p. 496), the above-mentioned scene and
roles were taken by Ichikawa Monnosuke I (dressed in *shibaraku* costume) and Tomizawa
Hansaburō. Tamazawa Rinya is known to have danced Dojōji and Hachinoki during the
eleventh month offerings. If the *Nempyō* is correct, the above identification is clearly in error.
The print is dated here to 1715 on the basis of style and technical matters.

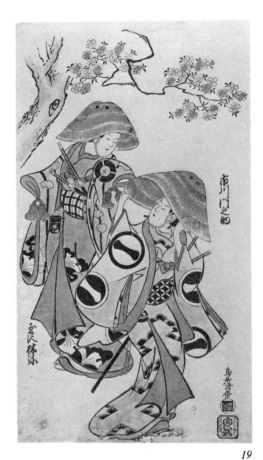

19

20 KIYOMASU I

Title: PLAYBILL OF THE NAKAMURA THEATRE
Date: 1715, second month
Technical: black and white vertical sheet, 51 × 31.5 cm.
Signature and Seals: Torii Kiyomasu, Kiyomasu
Inscription: Torii Kiyomasu, Kiyonobu's son (later addition
written with a brush)
Publisher: Hammoto (name omitted)-*ya*
James A. Michener Collection, Honolulu Academy of Arts

This *banzuke* (playbill) comes from the 1715 Nakamura-za production of *Bandō Ichi Kotobuki Soga*.
The actors depicted in the four scenes from the play are Ichikawa Danjūrō II, Tomizawa
Hansaburō, Ogawa Zengorō and the *onnagata*, Nakamura Takesaburō.

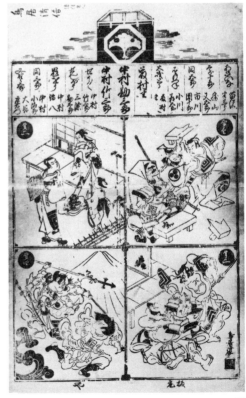

20

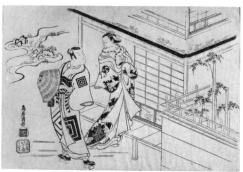

21

21 KIYOMASU I

Title: ICHIKAWA DANJŪRŌ II AS SOGA NO GORŌ AND NAKAMURA TAKESABURŌ AS KEWAIZAKA NO SHŌSHŌ
Date: 1715, second month
Technical: black and white horizontal *ōban*, 30.5 × 44.1 cm.
Signature and Seal: Torii Kiyomasu; Kiyomasu
Publisher: Motohama-chō Iga-*ya hammoto*
Clarence Buckingham Collection, Art Institute of Chicago

Soga no Gorō, played by Ichikawa Danjūrō II, appears in *komusō* (itinerant priest) garb beside Kewaizaka no Shōshō, played by Nakamura Takesaburō. Both actors, identified by *mon*, appeared together in the Nakamura production of *Bandō Ichi Kotobuki Soga*, which opened in the second month of 1715. The same design occurs in the Honolulu Academy of Arts Collection's *banzuke* of the play (No. 20, Kiyomasu I), and in two single sheets (Chicago, Kiyomasu 10; and Vever, Part II, No. 11).

22 KIYOMASU I

Title: NAKAMURA TAKESABURŌ AS KEWAIZAKA NO SHŌSHŌ AND ICHIKAWA DANJŪRO II AS SOGA NO GORŌ IN THE GARB OF A KOMUSŌ
Date: 1715, second month
Technical: black and white horizontal *ōban*, 28.8 × 42.5 cm.
Signature and Seal: Torii Kiyomasu; Kiyomasu
Publisher: Iga-*ya* Motohama-chō
Clarence Buckingham Collection, Art Institute of Chicago.

This fanciful treatment of a popular scene from the play, *Bandō Ichi Kotobuki Soga*, shows Nakamura Takesaburō as Shōshō standing in a garden looking at Ichikawa Danjūrō II as Soga no Gorō in the garb of a komusō playing the *shakuhachi* (wind instrument). The Japanese refer to this print as ''Moji Komusō'' (Komusō Disguise) since the folds of Danjūrō's robe are boldly rendered characters which read ''Ichikawa Yatsushi'' (Ichikawa in disguise). The playful calligraphic element common to Kiyomasu's work becomes almost an abstraction in this fine print. By the mid-1720s, many artists were utilizing a calligraphic line in their rendering of costume folds and in some instances the line became a cleverly disguised calligraphic symbol (see No. 31, Masanobu).

23 KIYOMASU I

Title: NUREGAMI CHŌZŌ (WET PAPER CHŌZŌ), ICHIKAWA
DANJŪRŌ II AS FUWA BANZAEMON AND NAKAMURA
TAKESABURŌ AS OKUNI
Date: mid 1710s
Technical: black and white horizontal *ōban*, 28.5 × 41.4 cm.
Signature and Seals: Torii Kiyomasu, Kiyomasu
Publisher: Yushima Tenjin Onnazaka no shita Komatsu-*ya*
James A. Michener Collection, Honolulu Academy of Arts

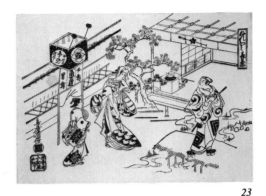

23

Ichikawa Danjūrō II as the samurai Fuwa Banzaemon and Nakamura Takesaburō as Okuni, the
founder of *Okuni-kabuki*, are depicted in a scene from the Nakamura-za production of *Mimasu
Nagoya* produced in the seventh month of 1715. The scene takes place in front of a kabuki
theater, the entrance *yagura* (drum tower) reading, "Okuni Kyōgen Tsukushi" (Plays of Okuni).
Below the *yagura* appears the inscription, "Onnamae Otokomae Okuni Kabuki" (Okuni Kabuki:
Dances by Women and Men). This print is from a group of horizontal *ōban* sheets by Kiyomasu
I, many of which are related to kabuki performances in 1715 and 1716.

24 KIYOMASU I

Title: UKIYO NARUKAMI (A STYLISH NARUKAMI):
ICHIKAWA DANJŪRŌ II AS NARUKAMI AND NAKAMURA
TAKESABURŌ AS PRINCESS TAEMA
Date: ca. 1715
Technical: black and white horizontal *ōban*, 29.3 × 40.3 cm.
Signature and Seals: Torii Kiyomasu, Kiyomasu
Publisher: Moto-hama-chō Iga-*ya hammoto*
James A. Michener Collection, Honolulu Academy of Arts

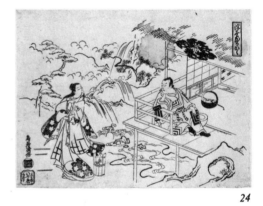

24

The scene, set at the mountain retreat of Saint Narukami, is from the 1715 Nakamura-za
production of *Narukami Shōnin,* with Narukami played by Ichikawa Danjūrō II and Princess
Taema by Nakamura Takesaburō. First written in 1684 by Ichikawa Danjūrō I, the play was
revised in 1698 by the author and enjoyed revivals in 1710, 1715, and 1726.

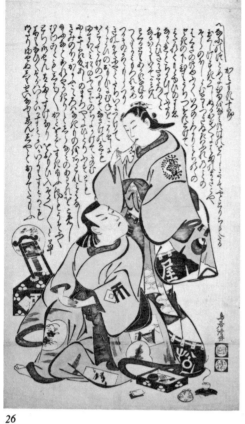

26

26 KIYOMASU I

Title: THE ACTORS KATSUYAMA MATAGORŌ AS JŪRŌ AND
FUJIMURA HANDAYŪ AS TORA
Date: ca. 1720
Technical: handcolored extra *ōban*, 56.4 × 33.2 cm.
Signature and Seal: Kiyomasu, Kiyomasu
Publisher: Sakai-chō Nakajima-*ya hammoto*
Hiraki Collection, Riccar Art Museum; Registered Important Art Object

The accompanying text leaves little doubt that this print depicts the famous haircombing
sequence between Soga no Jūrō and his mistress, Tora Gozen. The sequence was originally
created by the first Danjūrō in 1697. Yoshida Teruji assigns the print to the 1720 Ichimura-za
production of *Kamanari Nigiwai Soga (Lively Soga Drama Like the Roar of a Cauldron)*, but according
to contemporary record the roles were switched in a special *nuregoto* (love scene), and Jūrō
combed the hair of Tora. It is possible, of course, that the print was prepared ahead of the
opening performance before the scenario was changed and the roles reversed. A date in the
early 1720s seems plausible, both technically and stylistically.

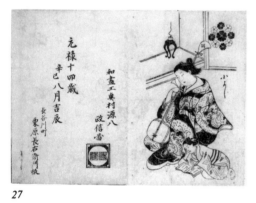

27

27 MASANOBU (ca. 1686-1764)

Title: HOKU RO MIKO CHO (BEAUTIFUL COURTESANS OF
THE NORTHERN GAY QUARTERS; titled by hand inscription)
Date: 1701, eighth month
Technical: black and white book, one volume incomplete, pages
mounted as *orihon* (folding album), sheets not
numbered, sixteen single-page *sumi* prints and
colophon, one double-page *sumi* print, 18.8 × 26.7 cm.
Signature and Seal: Yamato gakō Okumura Genpachi Masanobu
zu, Masanobu
Publisher: Kurihara Chōemon of Hasegawa-chō
James A. Michener Collection, Honolulu Academy of Arts

This rare album shows the influence of Kiyonobu's 1700 album *Keisei Ehon* (alternate reading,
Shōgi Gachō). The Masanobu version is designated as the first signed and dated work of the
artist. Another copy is known (Drukker Collection; Vever, Vol. I, pl. 11), also in *orihon* format,
as was originally intended. With the manuscript title, *Genroku Tayu Awase Kagami* (Genroku
Courtesans in Opposing Mirrors), it consists of sixteen single-page *sumi* prints and colophon.

28 MASANOBU

Title: THE ARRIVAL OF THE KOREAN EMBASSY
Date: ca. 1710
Technical: 12 black and white horizontal *ōban* sheets
mounted sequentially as a handscroll, each
approximately 28.3 × 36.5 cm.
Signature and Seal: Tōbu Yamato eshi Okumura Masanobu *zu*, Masanobu
(at lower right of first sheet)
Publisher: Ōdenma san chōme Tsuru-ya Kiemon *han*
James A. Michener Collection, Honolulu Academy of Arts

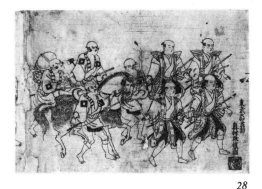

28

An official cavalcade from Korea with its curiously dressed foreigners is the subject of
Masanobu's superb black and white album. It is known in only one other copy (New York
Public Library), also signed Okumura Masanobu, which is in poor condition. The intact
Michener version offers important evidence for reattributing six sheets from the same set, now
housed in the Art Institute of Chicago, to Okumura Masanobu. The Chicago work bears the
spurious block signature "Torii Kiyonobu *hitsu*" and has been attributed to that important Torii
master in the past.

29 MASANOBU

Title: EBISU AND COURTESAN
Date: late 1700s
Technical: black and white horizontal *ōban*, 37 × 27 cm.
Signature: unsigned
Publisher: no mark
James A. Michener Collection, Honolulu Academy of Arts

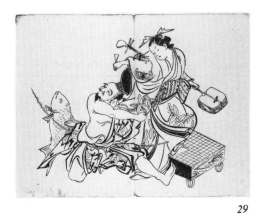

29

This is the third sheet from a signed album and depicts Ebisu, God of the Fisherman, holding
onto the kimono of a young girl who stands on a *goban* (a board for playing the game of *go*).
The scene is a *mitate* (parody) of the famous kabuki *kusazuribiki* acting sequence. This allusion is
clearly implied by the position of the courtesan, whose kimono decoration consists of butterfly
designs, the symbol of the kabuki protagonist, Soga Goro; and Daikoku, whose cap and pose
are associated with the kabuki role of Kobayashi Asahina.

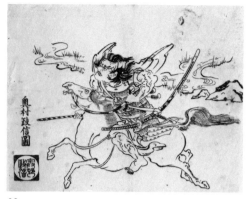

30

30 MASANOBU

Title: SOGA GORŌ (?) ON A HORSE
Date: late 1710s
Technical: black and white *ōban*, 35.1 × 26.5 cm.
Signature and Seal: Okumura Masanobu *zu*, Masanobu
Publisher: no mark
James A. Michener Collection, Honolulu Academy of Arts

Dealing with the impetuous hero, Soga Gorō, as told in *Wada No Saka Mori* (Wada's Banquet), an episode from the *Tale of the Soga Brothers*, this sheet is from an unrecorded album series. It is drawn in the bombastic style influenced by the early Torii.

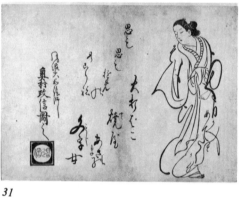

31

31 MASANOBU

Title: FIGURE OF A GIRL
Date: ca. 1715
Technical: black and white horizontal *ōban*, 37.7 × 27.1 cm.
Signature and Seal: Fūryū Yamato eshi (refined Japanese artist)
Okumura Masanobu *zu*; Masanobu
Publisher: no mark
Clarence Buckingham Collection, Art Institute of Chicago

The excesses of unrestrained calligraphic brushwork can be seen in this fine composition by Okumura Masanobu. Not unlike similar brushwork extravaganzas by Kiyomasu, the outline of the figure in this superb black and white single sheet is composed of calligraphic fragments of phrases used in letter writing by women; these include: *Medetaki Kashiko* (Happy Ending) and *Kaesu gaesu* (I implore repeatedly). The inscription above has been translated: "Think and think of the remnant of a dream." This work is a rarity.

32 MASANOBU

Title: WAKASHŪ SAMPUKUTSUI KOSHŌ FŪ
(THREE YOUNG MEN: A TEMPLE PAGE)
Date: ca. 1751
Technical: two-color *hosoban*, 29.6 × 14.8 cm.
Signature and Seal: Hōgetsudō Okumura Masanobu shōhitsu,
Tachōsai
Publisher: no mark
James A. Michener Collection, Honolulu Academy of Arts

The center panel of a triptych entitled "Wakashu Sampukutsui," this print depicts a man seated playing a hand drum. On the floor to his left is a book of five Nō plays, including *Takasago, Tamura* and *Ukai.* The poem reads: "Yubi ni tsuwa tsukete nariyoshi tsuzumigusa" (A drum is like a dandelion: a little spit on the fingers helps).

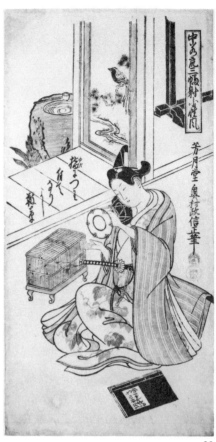

32

33 KIYONOBU II (active 1720s to ca. 1760)

Title: ICHIKAWA MASUGORŌ AND HAYAKAWA DENSHIRŌ
Date: 1727, eleventh month
Technical: handcolored *hosoban* with lacquer, 30.3 × 15.0 cm.
Signature: Torii Kiyonobu *hitsu* Ni-dai-me (second generation)
is written with a brush
Publisher: Maruko (abbreviation for Maru-*ya* Kohei)
Clarence Buckingham Collection, Art Institute of Chicago

The Nakamura-za production of *Yatsumune Taiheiki* was the occasion for the debut of seven-year old Ichikawa Masugorō, son of Ichikawa Danjūrō II. He is shown in the role of Kusunoki Tatewaki Masatsura, holding down the actor Hayakawa Denshirō in the role of Kyorori˙ Shinzaemon. The long inscription appearing in the upper portion of the print is Masatsura's monologue. (For a complete translation, see Binyon and Sexton, p. 167.) The work bears the brush addition of the term "ni-dai-me" (second generation). If the information is trustworthy, it has been suggested that the first Kiyonobu may have retired by 1727, the date of this print, and given his name to another member of the atelier, perhaps his son.

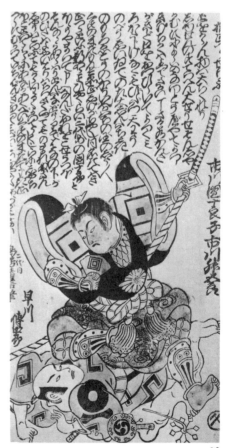

33

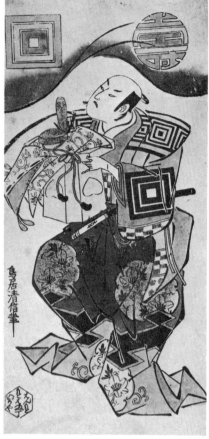

34

34 KIYONOBU II

Title: ICHIKAWA DANJŪRŌ II AS SOGA NO JŪRŌ SUKENARI
Date: 1733, first month
Technical: handcolored *hosoban*, 33.1 × 16.3 cm.
Signature: Torii Kiyonobu *hitsu*
Publisher: Hammoto Motohama-chō Iga-*ya*
Clarence Buckingham Collection, Art Institute of Chicago

The Art Institute of Chicago catalogue assigns this print to the Ichimura-za production of *Hanabusa Bunshin Soga*, performed from the first month of 1733. Danjūrō is shown in *kamishimo* (ceremonial dress) bearing a ceremonial stand on which are placed a robe and a nobleman's hat. Although finely designed and executed, this work lacks the strength of the first Kiyonobu's powerful composition.

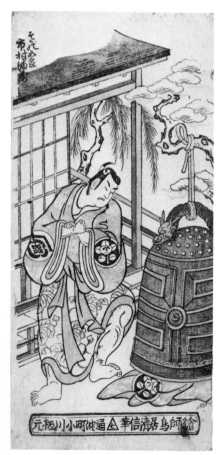

35

35 KIYONOBU II

Title: ICHIMURA MANZŌ AS SOGA NO GORŌ AND ICHIMURA UZAEMON VIII AS JŪRŌ
Date: 1745, first month
Technical: two-color *hosoban*, 31.8 × 15 cm.
Signature: Eishi Torii Kiyonobu *hitsu*
Publisher: Seal: Ogawa; Tōri Abura-chō Ogawa *hammoto*
James A. Michener Collection, Honolulu Academy of Arts

In the play *Hatsugoyomi Kotobuki Soga*, presented at the Ichimura-za in 1745, Ichimura Manzō acts the role of Soga no Gorō, identified by inscription, and Ichimura Uzaemon VIII plays Jūrō (hidden under a temple bell).

36 KIYONOBU II

Title: ONOE KIKUGORŌ I AS HANSHICHI AND
SAWAMURA SHIGENOI AS OHANA
Date: 1745, third month
Technical: two-color *hosoban*, 28.2 × 15 cm.
Signature: Torii Kiyonobu *hitsu*
Publisher: Sakai-chō Nakajima-*ya hammoto*
James A. Michener Collection, Honolulu Academy of Arts

Onoe Kikugorō (left) appears as Katanaya Hanshichi and Sawamura Shigenoi (right) as
Izutsuya Ohana, both identified by inscription, in a scene from the play, *Satogayoi Fujimi Saigyō*,
performed at the Ichimura-za in 1745.

36

37 KIYONOBU II

Title: ONOE KIKUGORŌ I AS HANSHICHI AND
SAWAMURA SHIGENOI AS OHANA
Date: 1745, third month
Technical: two-color *hosoban*, 32 × 15 cm.
Signature: Torii Kiyonobu *hitsu*
Publisher: Sakai-chō Nakajima-*ya hammoto*
James A. Michener Collection, Honolulu Academy of Arts

The young swordmaker's apprentice and his lover, Ohana, are shown standing beneath a
flowering tree in a scene from the same Ichimura-za production noted in No. 36. This and the
following print are printed with pink and a light greenish-brown color which seems to have
been used in place of the more common light green for a short period in the mid-1740s.

37

38

38 KIYONOBU II

Title: ONOE KIKUGORŌ I AS HANSHICHI AND
SAWAMURA SHIGENOI AS OHANA
Date: 1745, third month
Technical: two-color *hosoban*, 31.4 × 14.7 cm.
Signature: Torii Kiyonobu *hitsu*
Publisher: Sakai-chō Nakajima-*ya hammoto*
James A. Michener Collection, Honolulu Academy of Arts

Onoe Kikugorō (standing) as Katanaya Hanshichi and Sawamura Shigenoi (seated) as Izutsuya
Ohana, both identified by inscription, appear in a scene from the 1745 Ichimura-za production
of *Satogayoi Fujimi Saigyō* as noted in Nos. 36 and 37.

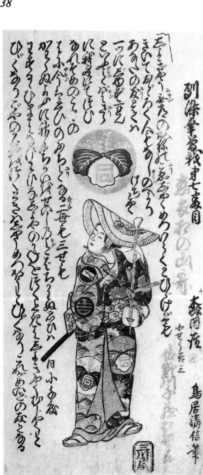

39

39 KIYONOBU II

Title: SANOGAWA SENZŌ AS KOSHŌ KICHIZA
Date: ca. 1747
Technical: two-color *hosoban*, 30.3 × 14 cm.
Signature: Torii Kiyonobu *hitsu*
Publisher: Mikawa-*ya*
James A. Michener Collection, Honolulu Academy of Arts

According to inscription, the print depicts Sanogawa Senzō in the role of the page Kichiza in
Act 7 of the play, *Naresome Saiwai Soga*. Although the play in question is not recorded in the
Kabuki Nempyō, it is known that Senzō played the part of Kichiza in a Morita-za production
given in 1747.

40 KIYONOBU II

Title: ICHIMURA UZAEMON VIII AS OGURI HANGAN AND
SEGAWA KIKUNOJŌ I AS TERUTE HIME
Date: 1747, eighth month
Technical: two-color *hosoban*, 29.5 × 14.1 cm.
Signature: Eshi Torii Kiyonobu *hitsu*
Publisher: Seal: Yama (mark of the publisher Maruya Kohei);
Ōdenma Sanchōme Yamamoto *hammoto*
James A. Michener Collection, Honolulu Academy of Arts

Ichimura Uzaemon VIII as Oguri (standing) and Segawa Kikunojō as Terute no hime (seated)
are identified by inscription. According to the *Kabuki Nempyō* (Vol. 2, p. 529), Uzaemon
appeared as Oguri Hangan and Kikunojō as Terute no hime in the 1747 Ichimura-za production
of *Mangetsu Oguri Yakata*.

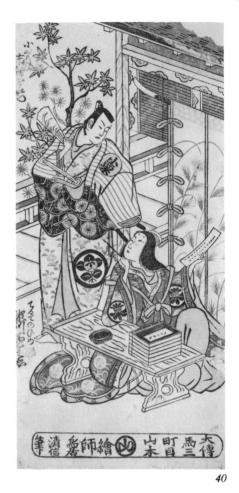

40

41 KIYOMASU II (active mid 1720s-early 1760s)

Title: YAMASHITA KINSAKU IN THE ROLE OF HANJO
Date: mid-1720s
Technical: handcolored *hosoban*, 31.1 × 15.4 cm.
Signature: Torii Kiyomasu *hitsu*
Publisher: no mark
James A. Michener Collection, Honolulu Academy of Arts

The *onnagata*, Yamashita Kinsaku, in the role of the poetess Hanjo, identified by inscription, is
seated in front of a potted tree holding a group of fans, one of which includes the inscription,
"ippon gaokujō" (the very best). In the foreground is an open fan box and another unopened
box with the character "yama" (for Yamashita) appearing on one side and the actor's *mon* on
the other.

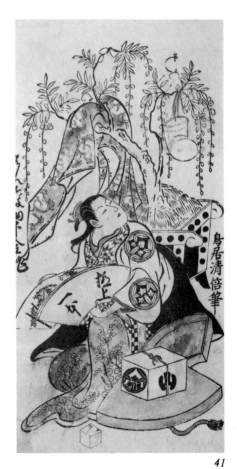

41

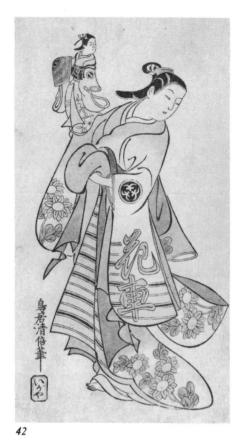

42

42 KIYOMASU II

Title: UNIDENTIFIED ACTOR HOLDING A PUPPET
Date: Mid-1720s
Technical: handcolored *hosoban*, 13.8 × 16 cm.
Signature: Torii Kiyomasu *hitsu*
Publisher: Iga-ya
James A. Michener Collection, Honolulu Academy of Arts

An unidentified *onnagata* holds a puppet representing the actor, Ichikawa Monnosuke, in *komusō* garb with an *amikasa* (basket hat). The design was issued before the time of Monnosuke's retirement in 1727.

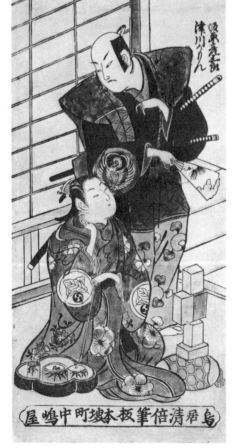

43

43 KIYOMASU II

Title: BANDO HIKOSABURŌ AND TSUGAWA KAMON
Date: late 1720s
Technical: handcolored *hosoban*, 32.5 × 16 cm.
Signature: Torii Kiyomasu *hitsu*
Publisher: Hammoto Sakai-chō Nakajima-*ya*
James A. Michener Collection, Honolulu Academy of Arts

Bando Hikosaburō is looking down at Tsugawa Kamon, who has just balanced several blocks on a pillow, in a scene from an unidentified play presented in the late 1720s.

44 KIYOMASU II

Title: SEGAWA KIKUNOJŌ AS OISO NO TORA
Date: ca. 1737, first month
Technical: handcolored *hosoban*, 31.4 × 14.8 cm.
Signature: Eshi Torii Kiyomasu *hitsu*
Publisher: Seal: Urokogata; Urokogata-*ya hammoto*
James A. Michener Collection, Honolulu Academy of Arts

Segawa Kikunojō as Oiso no Tora is identified by the inscription, "Oiso no Tora Shirokiya-e miuke serare Naigi Otora to naru; nibanme odeke, Segawa Kikunojō" (Oiso no Tora is redeemed from the Shirokiya and becomes the housewife Otora; brilliantly performed in the second play by Segawa Kikunojō). The actor performed the role of Tora in several Soga plays in the mid-to-late 1730s, including the *sewamono* section of the 1737 Nakamura-za production of *Momo Asobi Monbi no Kaidori.*

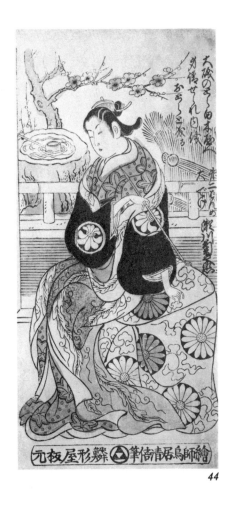

44

45 KIYOMASU II

Title: SEGAWA KIKUJIRŌ AS SHIROKIYA OKUMA
Date: ca. 1737, first month
Technical: handcolored *hosoban* with lacquer, 31.6 × 14.6 cm.
Signature: Eshi, Torii Kiyomasu *hitsu*
Publisher: Urokogata-*ya hammoto*
James A. Michener Collection, Honolulu Academy of Arts

The *onnagata*, Segawa Kikujiro, appears in the role of Shirokiya Okuma, identified by inscription, possibly in the play, *Momo Asobi Monbi no Kaidori*, presented at the Nakamura-za in the first month of 1737 (see No. 44).

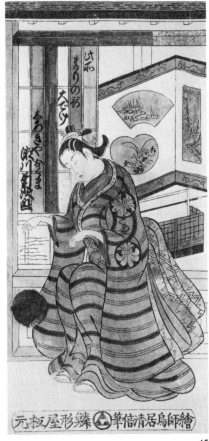

45

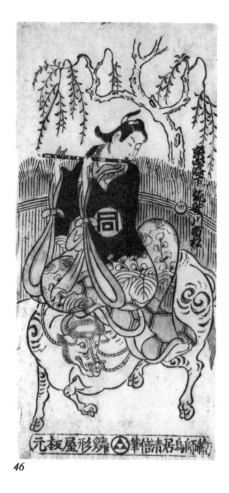

46

46 KIYOMASU II

Title: SANOGAWA ICHIMATSU I AS KUMENOSUKE
Date: 1741, second month
Technical: handcolored *hosoban*, 31.2 × 14.8 cm.
Signature: Eshi Torii Kiyomasu *hitsu*
Publisher: Seal: Urokogata; Urokogata-*ya hammoto*
James A. Michener Collection, Honolulu Academy of Arts

Sanogawa Ichimatsu I, playing a flute, is shown seated on an ox. The actor is identified by the inscription: "Kyō Shijō Kudari, Sanogawa Ichimatsu" (Sanogawa Ichimatsu from Shijō in Kyoto). The print records Ichimatsu's Edo debut in the 1741 Nakamura-za production of *Na no Hana Akebono Soga.*

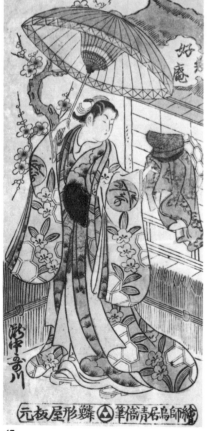

47

47 KIYOMASU II

Title: TAKINAKA KASEN AS OIWA
Date: 1741, eleventh month
Technical: handcolored *hosoban*, 31.4 × 14.9 cm.
Signature: Eshi Torii Kiyomasu *hitsu*
Publisher: Seal: Urokogata; Urokogata-*ya hammoto*
James A. Michener Collection, Honolulu Academy of Arts

The *onnagata,* Takinaka Kasen, plays the role of the mask maker Oiwa at Kenkō-an (the residence of Kenkō) in the 1741 production of *Enya Hangan Kokyō Nishiki.*

48 KIYOMASU II

Title: SAWAMURA SŌJŪRŌ AS IMAKAWA NAKAAKI AND
NAKAMURA TOMIJŪRŌ AS THE COURTESAN, SAKURAGI
Date: intercalary 1743, fourth month (according to inscription)
Technical: two-color *hosoban*, 31.8 × 14.9 cm.
Signature: Torii Kiyomasu *hitsu*
Publisher: Sakai-chō Nakajima-*ya hammoto*
James A. Michener Collection, Honolulu Academy of Arts

The actor, Sawamura Sōjūrō (left), is depicted in the role of Imakawa Nakaaki and the
onnagata, Nakamura Tomijūrō, as Keisei Sakuragi, identified by inscription, along with the
jōruri (narrative song accompanied by *samisen*) chanter, Mojidayū, in a scene from an
unidentified play presented in 1743. The date is based on a contemporaneous manuscript
inscription. This is secure evidence for dating the beginning of color printing to this general
time.

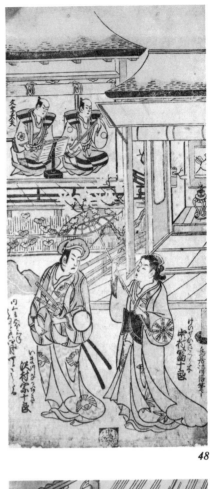

48

49 KIYOMASU II

Title: SEGAWA KIKUJIRŌ AS THE COURTESAN, KATSURAGI
Date: 1751 (re-publication of a 1746 design)
Technical: handcolored *hosoban*, 31.4 × 14.8 cm.
Signature: Eshi Torii Kiyomasu *hitsu*
Publisher: Seal: Urokogata; Urokogata-*ya hammoto*
James A. Michener Collection, Honolulu Academy of Arts

The *onnagata*, Segawa Kikujirō, appears as Katsuragi in the 1751 (ninth month) Nakamura-za
production of *Keisei Fukubiki Nagoya*, a memorial performance for Segawa Kikunojō I, who had
performed the scene a few years earlier. The inscription reads: "Segawa Kikujirō Muken no
kane Oatari" (Segawa Kikujirō achieving a great success in *The Bell of Hades*). The last two
characters of the name Kikujirō seem to be alterations, however, and the print seems to be a
reissue of a design first published in 1746 commemorating Segawa Kikunojō's interpretation of
the role in that year.

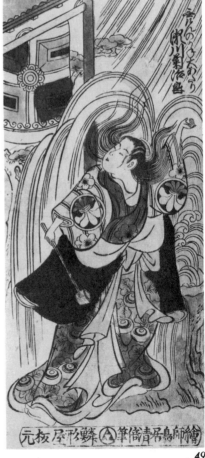

49

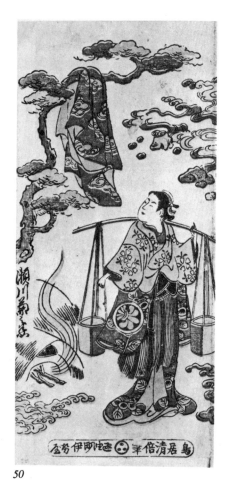

50

50 KIYOMASU II

Title: SEGAWA KIKUNOJŌ II AS MATSUKAZE
Date: 1760 (?), autumn
Technical: two-color *hosoban*, 30.2 × 14.3 cm.
Signature: Torii Kiyomasu *hitsu*
Publisher: Seal: Ise; Tori Abura-chō Ise-*ya*
Clarence Buckingham Collection, Art Institute of Chicago

In the autumn of 1760, the Nakamura-za produced the play, *Yamatogana Ariwara Keizu,* the story of the famous poet Ariwara no Yukihira. In exile Ariwara met Murasame and Matsukaze, sisters who were drawers of salt water for kilns. When the poet departed from the sisters he left his nobleman's coat as a means of promising his return. Kiyomasu depicts Segawa Kikunojō II as Matsukaze gazing up at Ariwara's coat, hanging from the limb of a tree. Kikunojō also appeared in the same role in the 1756 production of *Kaeribana Konno Sakura,* adding uncertainty to the identification offered by the cataloguers of the Buckingham Collection. No matter which identification is correct, the present print would appear to be the last surviving work of the second artist to bear the name Kiyomasu.

51 KIYOTADA (active 1720s-1740s)

Title: OSOME AND HISAMATSU
Date: ca. 1719
Technical: handcolored *hosoban,* 31.8 × 16.1 cm.
Signature: Torii Kiyotada
Publisher: no mark
James A. Michener Collection, Honolulu Academy of Arts

The maiden Osome tends a *hiemaki* (toy garden) while her lover Hisamatsu holds a toy crane to place beside the scarecrow in the tray. A love letter protrudes from his kimono. This print was probably published in the autumn of 1719 at the time of the Nakamura-za production of *Osome Hisamatsu Shinju,* although the print does not actually record the performance.

51

52 KIYOTADA

Title: YOUNG WOMAN WITH LIBRETTO
Date: ca. 1719
Technical: handcolored *hosoban*, 28.4 × 14.3 cm.
Signature: Torii Kiyotada
Publisher: Iga-ya
James A. Michener Collection, Honolulu Academy of Arts

The design shows a young woman holding a libretto titled "Abura-ya Osome Utazaimon," a reference to the Nakamura-za production of *Osome Hisamatsu Shinju,* first performed in Edo in 1719 (see No. 51). For the people of Edo living in the Kyōhō era this print evoked memory of two important romantic tragedies commemorated in kabuki. First, the love-suicide of Osome and Hisamatsu is suggested by the young woman's libretto which includes a line from the 1719 Nakamura-za production of *Osome Hisamatsu Shinju.* A more oblique reference to another pair of lovers, Yao-ya Oshichi and Kichisaburō is suggested by the hero and heroine's emblems cleverly worked into the pattern of the young woman's kimono. Such hidden meaning surely adds to the overall impression of this print and clarifies the ultimate intention of its designer. It becomes certain, moreover, that this print does not record a specific kabuki performance. Edo was a world so fascinated by fixed recurrent motifs that artists delighted in recasting them in situation after situation. The combination of motifs points to a period of time when both love stories were fashionable in the minds of the Edo public—we have been able to date this print accordingly.

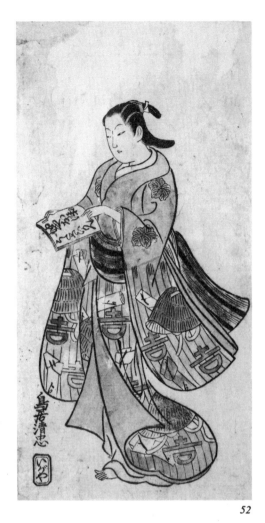

52

53 KIYOTADA

Title: INTERIOR OF THE ICHIMURA THEATER
Date: ca. 1738
Technical: handcolored extra *ōban*, 49.0 × 69.4 cm.
Signature: Eshi Torii Kiyotada *hitsu*
Engraver: Chōkō Tsurumi Kashichirō
Publisher: Urokogata-ya
Hiraki Collection, Riccar Art Museum; Important Art Object.

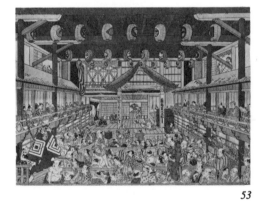

53

Although the stage sign announcing the performance of this superb *uki-e* (perspective) print reads *Tsuru Kame Mitsugi Taiheiki,* Seiichiro Takahashi tentatively connects the print with the 1738 Ichimura-za production of *Mitsugi Bune Taiheiki.* Technically, stylistically and iconographically such a date is plausible; however, it would place Kiyotada's *uki-e* achievement two years before that of Masanobu, who is the supposed inventor of this compositional form. The *shibaraku* costume is of the fully developed type common from around this time onward. The purple handcoloring of the costume may suggest that this impression was printed at a slightly later date.

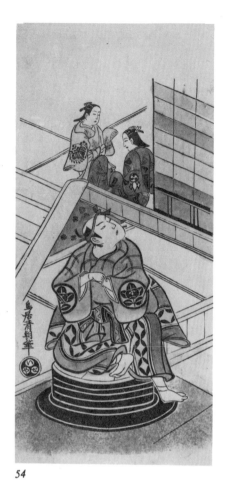

54

54 KIYOTOMO (active 1720s-1740s)

Title: ICHIMURA TAKENOJŌ IV, HAYAKAWA HATSUSE
AND NAKAMURA TAKESABURŌ
Date: early 1720s
Technical: handcolored *hosoban*, 32.7 × 15.2 cm.
Signature: Torii Kiyotomo *hitsu*
Publisher: Ise-ya
James A. Michener Collection, Honolulu Academy of Arts

Ichimura Takenojō is seated on a cooking cauldron. To the back, on an open balcony, are
Hayakawa Hatsuse (left) and Nakamura Takesaburō. The roles may be those of Soga Gorō and
the courtesans Yawata and Tora in the 1721 Ichimura-za production of *Tsurukame Wakayagi Soga*.

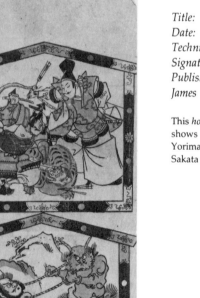

55

55 KIYOTOMO

Title: LEGENDARY HISTORICAL THEMES
Date: 1720s
Technical: handcolored *hosoban*, 33.7 × 15.6 cm.
Signature: Torii Kiyotomo *hitsu*
Publisher: Hammoto Nakajima-ya
James A. Michener Collection, Honolulu Academy of Arts

This *hosoban* print depicts two votive plaques, possibly intended as cut-outs. The upper plaque
shows Minamoto Yorimasa looking on as I no Hayata slays the *nue* (mythical being) that
Yorimasa had shot down when it threatened the Imperial Palace. The lower plaque shows
Sakata Kintoki, one of the four legendary retainers of Yorimitsu, in a tug-of-war with a devil.

56 KIYOTOMO

Title: YAMAMOTO KOHEIJI WITH PUPPET
Date: ca. 1732
Technical: handcolored *hosoban*, 31.8 × 15.9 cm.
Signature: Torii Kiyotomo *hitsu*
Publisher: Nakajima-*ya*
James A. Michener Collection, Honolulu Academy of Arts

The puppeteer, Yamamoto Koheiji, identified by inscription, is shown manipulating a female puppet. The cartouche identifies the troupe to which Koheiji belonged as the Ōsaka Dewa troupe led by Dewanojō. Richard Lane notes that this troupe performed in the Sakai-chō district of Edo in 1732.

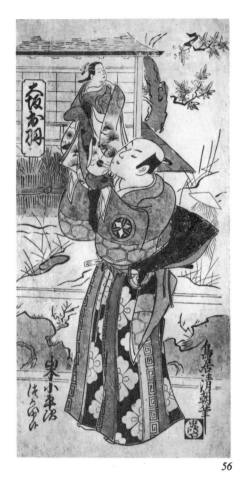

56

57 KIYOHIRO (active 1750s-1760s)

Title: NAKAMURA SUKEGORŌ AS ŌMORI HIKOSHICHI MORINAGA AND NAKAMURA TOMIJŪRŌ AS KASUGANO NO FUJI
Date: 1753, eleventh month
Technical: two-color *hosoban*, 28.6 × 14.2 cm.
Signature: Torii Kiyohiro *ga*
Publisher: Yamamoto *han*
James A. Michener Collection, Honolulu Academy of Arts

Nakamura Sukegorō (right) appears in the role of Ōmori Hikoshichi Morinaga and Nakamura Tomijūrō as Kasugano no Fuji, both identified by inscription, in the 1753 Nakamura-za production of *Hyakumanki Tsuwamono Taiheiki.* (Tomijūrō's role is listed in kabuki record as "Shirabyoshi O'Fuji").

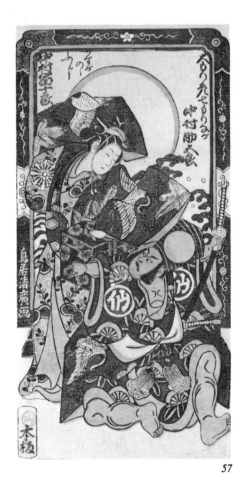

57

58

58 KIYOHIRO

Title: THREE YOUNG GIRLS OF FUKAGAWA
Date: ca. 1755
Technical: two-color *hosoban* triptych, 30.8 × 43.0 cm.
Signature: Torii Kiyohiro *hitsu*
Publisher: Sakai-*ya*
Hiraki Collection, Riccar Art Museum; Important Art Object

Okumura Masanobu and Nishimura Shigenaga are credited with the adaption of the *hosoban* triptych format from Japanese painting during the period of *urushi-e*. Torii artists such as Kiyomitsu, the third titular head of the school, and his talented pupil, Torii Kiyohiro, utilized this format with great skill for their two-color *benizuri-e* compositions. The present design is of considerable interest since it is one of a small group of compositions signed Torii Kiyohiro that is identical with designs by Torii Kiyomitsu.

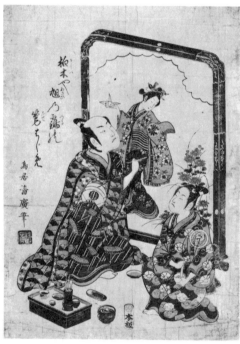

60

60 KIYOHIRO

Title: ONOE KIKUGORŌ I AND BANDŌ HIKOSABURŌ II PAINTING THE FIGURE OF SEGAWA KIKUJIRŌ ON A SCREEN
Date: ca. 1754, first month
Technical: two-color *ōban*, 43.6 × 30.9 cm.
Signature and Seal: Torii Kiyohiro *hitsu*, Kiyohiro
Publisher: Yamamoto *han*
James A. Michener Collection, Honolulu Academy of Arts

Onoe Matsusuke is painting a picture of Segawa Kikujirō, holding a paper crane, on a *tsuitate* (free-standing screen). Bando Hikosaburō appears as a boy grinding colors. The poem reads, "Kashiwagiya asahi no tsuru no fude hajime" (The first calligraphy of the oak tree and the crane of the rising sun). Kikugorō's crest was a pair of oak leaves and Hikosaburō's crest was a crane in a circle shaped like the rising sun. The "first calligraphy" refers to the first ceremonial inscription of the New Year, but in this case it seems to mean that Kikugorō and Hikosaburō were "writing" or acting together for the first time, in a New Year's play. The scene is not recorded in theatrical records, but the print is of great interest in showing a painter of the period at work. No other impression of the print is known.

61 KIYOHIRO

Title: COUPLES UNDER UMBRELLAS
Date: early 1750s.
Technical: two-color uncut triptych, 28.7 × 43.6 cm.
Signature: Torii Kiyohiro *hitsu*
Publisher: Tōri-aburo-chō Maruko han (Maru-*ya* Kohei)
James A. Michener Collection, Honolulu Academy of Arts

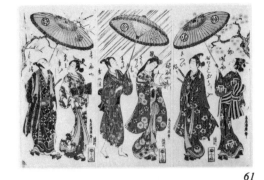

61

The left panel depicts Ichimura Kamezō holding an umbrella for Nakamura Kumetarō under plum blossoms. The center panel shows Sanogawa Ichimatsu holding an umbrella for Nakamura Tomijūrō I. The right panel shows Segawa Kikujirō, a maid-servant, holding an umbrella for Arashi Otohachi who is dressed as a *wakashū*. Kiyohiro's print seems to be a graceful grouping of six of the most popular and attractive young actors of the day.

62 KIYOHIRO

Title: ONOE KIKUGORŌ AS GOINOSUKE TAKENARI
Date: 1754, eleventh month
Technical: two-color *hosoban*, 28 × 13.3 cm.
Signature: Torii Kiyoshiro *hitsu*
Publisher: Yamamoto *han*
James A. Michener Collection, Honolulu Academy of Arts

Onoe Kikugorō appears as Goinosuke Takenari, disguised as a radish seller, in the second half of the 1754 Ichimura-za production of *Keisei Asakusa Kagami.*

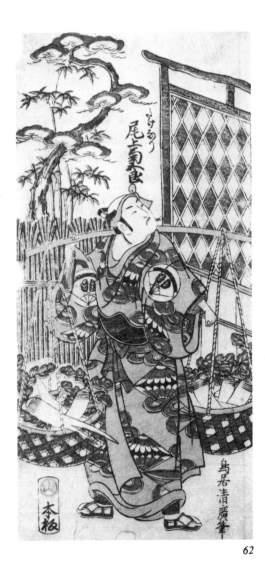

62

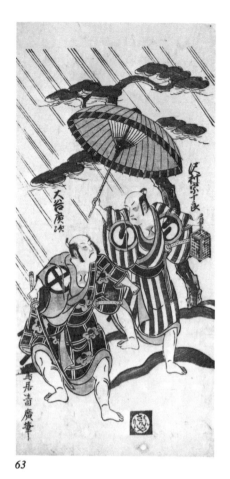

63

63 KIYOHIRO

Title: SAWAMURA SOJŪRŌ II AND ŌTANI HIROJI II
Date: ca. 1754-1755
Technical: two-color *hosoban*, 31.4 × 14.5 cm.
Signature: Torii Kiyohiro *hitsu*
Publisher: Sakai-*ya hammoto*
James A. Michener Collection, Honolulu Academy of Arts

Sawamura Sojūrō is holding an umbrella in his right hand to shield his companion from a summer rain and in his left a cage containing fireflies or insects. Ōtani Hiroji appears to the left, his sword unsheathed. The print probably records one of their 1754-1755 performances.

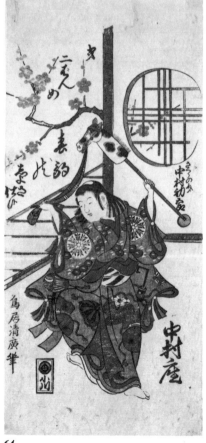

64

64 KIYOHIRO

Title: NAKAMURA HATSUGORŌ AS SAKURANOSUKE
Date: ca. 1754 or 1755
Technical: two-color *hosoban*, 28.6 × 14.2 cm.
Signature: Torii Kiyohiro *hitsu*
Publisher: Kogawa
James A. Michener Collection, Honolulu Academy of Arts

The inscription on the print states that Nakamura Hatsugorō appears as Sakuranosuke performing a *harukoma*, or spring pony dance, in the second half (*nibanme*) of a spring play. This print may mark either his debut in the first month of 1754, or his first appearance following his success as Tsurumatsu in the first month of 1755.

65 KIYOHIRO

Title: SEGAWA KIKUNOJŌ II
Date: late 1750s
Technical: two-color *hashira-e*, 66.2 × 10 cm.
Signature and Seal: Torii Kiyohiro *ga*, Kiyohiro
Publisher: Bakurōchō itchome Shōkaku dō Yamashiro *hammoto*
James A. Michener Collection, Honolulu Academy of Arts

Segawa Kikunojō is seen in a female role wearing two swords. Another impression, perhaps a
different block, with Kiyohiro's signature replaced by Kiyomitsu's and Yamashiro's mark
replaced by that of the publisher, Enami, is in the Clarence Buckingham Collection of the Art
Institute of Chicago.

65

66 KIYOSHIGE (active late 1720s-early 1760s)

Title: ICHIKAWA YAOZŌ I AS SOGA NO GORŌ
Date: 1752, first month
Technical: two-color *hosoban*, 39.1 × 17.5 cm.
Signature and Seal: Torii Kiyoshige, Kiyoshige
Publisher: Yamamoto *han*
James A. Michener Collection, Honolulu Academy of Arts

Ichikawa Yaozō (Kajō) plays Soga no Gorō in the 1752 Nakamura-za production of *Kuruwa
Kuruwa Akinai Soga*. A cryptic message occurs in a poem accompanying this powerful portrait of
Ichikawa Yaozō. The poem translates: "The flowering azaleas of old Matsushima; they bloom in
two colors." The verse is a poetically disguised reference to the actor's name change from
Matsushima to Ichikawa Yaozō in the eleventh month of 1749. This reference, incidentally,
helped in dating the print to Yaozō's first performance of Gorō after the name change in 1752.
Add to this elegantly disguised reference the fluid line and sophistication of the woodblock
carving common to the late Torii style and you have some sense of the intellectual and aesthetic
pleasure this print provided for its Edo audience.

67

67 KIYOSHIGE

Title: BANDŌ HIKOSABURŌ (II)
Date: ca. 1758, first month
Technical: two-color *hosoban*, 39.7 × 17.5 cm.
Signature and Seal: Torii Kiyoshige, Kiyoshige
Publisher: Maru-*ya* Yamamoto Kohei
Hiraki Collection, Riccar Art Museum; Important Art Object

The actor, Bandō Hikosaburō (II), identified by *mon* and inscription, appears in the role of a young warrior, perhaps that of Izu no Saburō, in the 1758 Ichimura-za production of *Kujūsanki Oyose Soga (The Soga Reprisal Against the Ninety-three Warriors)*. The inscription also includes Hikosaburō's alternate name Shinsui; both names were assumed following the death of Hikosaburō I in 1751.

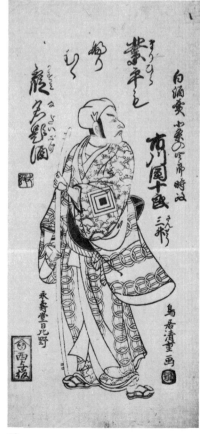

68

68 KIYOSHIGE

Title: ICHIKAWA DANJŪRŌ IV AS HŌJŌ NO SHIRŌ TOKIMASA
Date: 1761, third month
Technical: *Hosoban* with faded color, 31.3 × 14.6 cm.
Signature and Seal: Torii Kiyoshige *ga*, Kiyoshige
Publisher: Eijudō hibino Nishiyo *han* (Nishimura-*ya* Yochachi)
James A. Michener Collection, Honolulu Academy of Arts

Ichikawa Danjūrō IV (Sanshō) portrays Hōjō Shirō Tokimasa disguised as a *shirozake-uri* (sake seller), in the second play of *Edo Murasaki Kongen Soga*, titled *Sukeroku Yukari no Edo Zakura*, presented at the Ichimura-za from the third month of 1761.

69 KIYOMITSU I (ca. 1735-1785)

Title: ICHIMURA KAMEZŌ AS YUKIHIRA AND NAKAMURA
TOMIJŪRŌ I AS MATSUKAZE
Date: 1757, eleventh month
Technical: two-color *hosoban*, 30.6 × 14.3 cm.
Signature: Torii Kiyomitsu *hitsu*
Publisher: Urokogata-*ya hammoto*
James A. Michener Collection, Honolulu Academy of Arts

Ichikawa Kamezō as Yukihira is shown kneeling before the *onnagata,* Nakamura Tomijūrō I as
Matsukaze, both identified by inscription, in a scene from the 1757 Ichimura-za production of
Matsu wa Taiyu Suma no Wakezato.

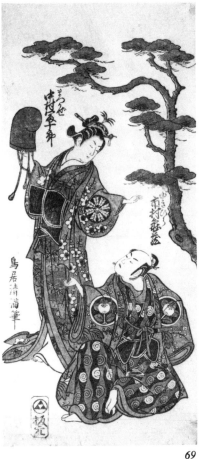

69

70 KIYOMITSU I

Title: ICHIKAWA DANJŪRŌ IV AS ABURAYA KUHEIJI AND
ONOE KIKUGORŌ AS HIRANOYA TOKUBEI
Date: 1758, first month
Technical: two-color *hosoban*, 37.3 × 17.4 cm.
Signature and Seal: Torii Kiyomitsu, Kiyomitsu
Publisher: Maruko
James A. Michener Collection, Honolulu Academy of Arts

Ichikawa Danjūrō IV (right) as Aburaya Kuheiji, alias Kagekiyo, and Onoe Kikugorō as
Hiranoya Tokubei, alias Shigetada, appear in the 1758 Nakamura-za production of *Tokitsukara
Irifune Soga.*

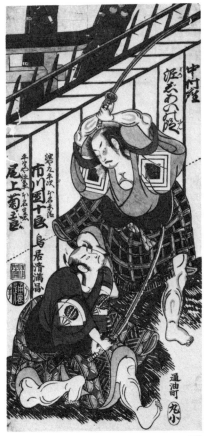

70

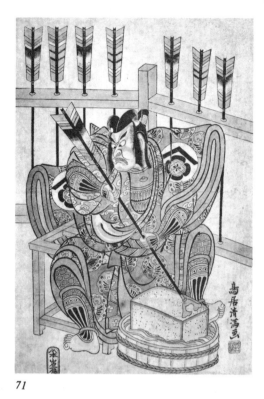

71

71 KIYOMITSU I

Title: ICHIKAWA EBIZŌ (DANJŪRŌ II) AS YANONE GORŌ
Date: 1758, third month
Technical: three-color *ōban*, 41.7 × 28.7 cm.
Signature and Seal: Torii Kiyomitsu *ga*, Kiyomitsu
Publisher: Yamamoto Iwato-*ya*
James A. Michener Collection, Honolulu Academy of Arts

This print depicts Ichikawa Ebizō (Danjūrō II) possibly as the spirit of Soga no Gorō sharpening an arrow in the 1758 Ichimura-za production of *Koizome Sumidagawa*, the actor's last performance on stage.

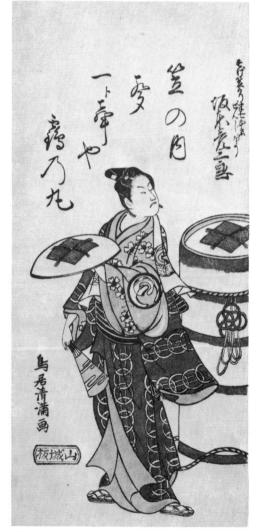

72 KIYOMITSU I

Title: BANDŌ HIKOSABURŌ II AS THE HATSELLER HANSHICHI
Date: 1760, third month
Technical: two-color *hosoban*, 31.4 × 14.2 cm.
Signature: Torii Kiyomitsu *ga*
Publisher: Yamamoto *han*
James A. Michener Collection, Honolulu Academy of Arts

Bandō Hikosaburō II portrays the sedge hatseller, Hanshichi (actually Zenjibō), in the 1760 Ichimura-za production, *Soga Mannen Bashira*.

73 KIYOMITSU I

Title: ICHIKAWA RAIZŌ I AS SHIRAGIKU, A FERN SELLER
Date: 1762
Technical: two-color *hosoban*, 31.6 × 14.4 cm.
Signature: Torii Kiyomitsu *ga*
Publisher: Sakai-*ya*
James A. Michener Collection, Honolulu Academy of Arts

The ghost of Shiragiku is seen in a dance included in the 1762 Nakamura-za performance of
Soga Hiiki Nihon Zakura.

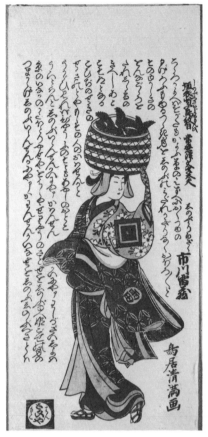

73

74 KIYOMITSU I

Title: ICHIMURA UZAEMON IX AS TERAOKA HEIEMON
Date: autumn, 1762
Technical: three-color *hosoban*, 30.8 × 13.9 cm.
Signature: Torii Kiyomitsu *ga*
Publisher: no mark
James A. Michener Collection, Honolulu Academy of Arts

Ichimura Uzaemon IX, identified by inscription, appears as Teraoka Heiemon probably in the
autumn, 1762 Ichimura-za performance of *Kanadehon Chushingura*. Although the role of
Heiemon was not popular according to theatrical records, it is a more plausible assignment than
the role of Tadanobu in the 1763 performance suggested in the catalogue of the Buckingham
Collection at the Art Institute of Chicago.

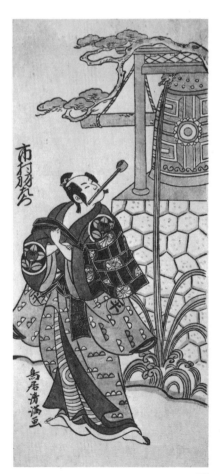

74

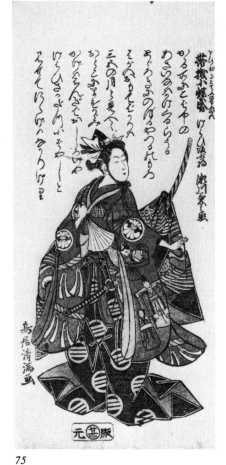

75

75 KIYOMITSU I

Title: SEGAWA KIKUNOJŌ II AS KEWAIZAKA SHŌSHŌ
Date: 1763, second month
Technical: three-color *hosoban*, 31.3 × 14.1 cm.
Signature: Torii Kiyomitsu *ga*
Publisher: Maru-*ya hammoto*
James A. Michener Collection, Honolulu Academy of Arts

Segawa Kikunojō II appears dressed as Asahina, but in reality is Soga no Gorō's lover, Kewaizaka Shōshō, in *Obihiki Kochō no Yugure,* the *jōruri* performed during the 1763 Nakamura-za production of *Fūjibumi Sakae Soga.*

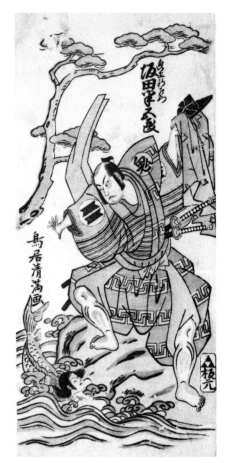

76

76 KIYOMITSU I

Title: SAKATA HANGORŌ AS ONIO SHINZAEMON
Date: 1763, second month
Technical: three-color *hosoban*, 29.8 × 14 cm.
Signature: Torii Kiyomitsu *ga*
Publisher: Urokogata-*ya hammoto*
James A. Michener Collection, Honolulu Academy of Arts

Sakata Hangorō plays Onio Shinzaemon, identified by inscription, in the 1763 Nakamura-za production of *Momochidori Ōiso Kayoi.*

77 KIYOMITSU I

Title: OTANI HIROJI AS SAKATA NO KINTOKI AND
ONOE MATSUSUKE AS BIJO GOZEN
Date: 1765, eleventh month
Technical: two-color *hosoban*, 29.5 × 14.2 cm.
Signature: Torii Kiyomitsu *ga*
Publisher: Kichi Uemura
James A. Michener Collection, Honolulu Academy of Arts

Otani Hiroji as Sakata no Kintoki dressed as a Sambasō dancer and Onoe Matsusuke, holding a
small hand drum, as Bijo Gozen appear in a dance scene from the 1765 Ichimura-za production
of *Furitsumuhana Nidai Genji.*

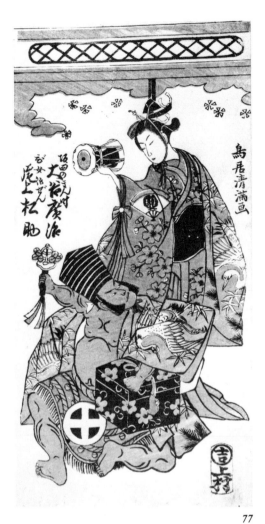

77

78 KIYOMITSU I

Title: STANDING MALE FIGURE IN KOMUSO GARB
Date: late 1750s or early 1760s
Technical: two-color *hashira-e*, 64.5 × 10.3 cm.
Signature and Seal: *Shoga* Torii Kiyomitsu *hitsu,* Kiyomitsu
Publisher: Urokogata-*ya hammoto*
James A. Michener Collection, Honolulu Academy of Arts

This design, showing a male figure in *komuso* garb, is very similar to a Kiyomitsu print of
Segawa Kikunojō II dressed in the same manner.

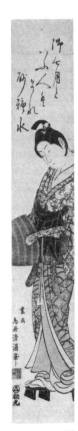

78

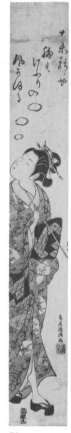

79

79 KIYOMITSU I

Title: COURTESAN BLOWING SMOKE RINGS
Date: late 1750s or early 1760s
Technical: two-color *hashira-e*, 70.1 × 10.1 cm.
Signature and Seal: Torii Kiyomitsu *ga*, Kiyomitsu
Publisher: Urokogata-*ya hammoto*
James A. Michener Collection, Honolulu Academy of Arts

A courtesan is seen holding a long pipe in her right hand and blowing smoke rings into the air.

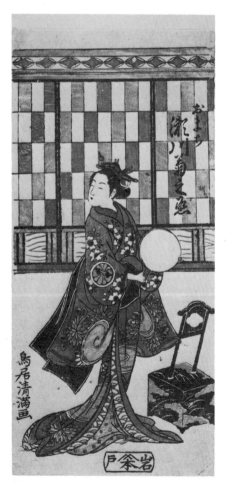

80

80 KIYOMITSU I

Title: SEGAWA KIKUNOJŌ II AS OMACHI
Date: 1765, eleventh month
Technical: three-color *hosoban*, 30 × 14 cm.
Signature: Torii Kiyomitsu *ga*
Publisher: Iwato
James A. Michener Collection, Honolulu Academy of Arts

The famed *onnagata*, Segawa Kikunojō II, as Omachi, the sister of Godai Saburō, is standing before a cosmetic box holding a round hand mirror in the 1765 Nakamura-za production of *Kagura Uta Amagoi Komachi*.

81 KIYOMITSU I

Title: ICHIKAWA DANJŪRŌ IV AS KAGEKIYO
Date: mid-1760s
Technical: Three-color *hosoban*, 29.3 × 13 cm.
Signature: Torii Kiyomitsu *ga*
Publisher: Ise-*ya*
James A. Michener Collection, Honolulu Academy of Arts

Ichikawa Danjūrō IV appears as Kagekiyo, a role which the actor took several times throughout his career. On stylistic grounds, a date in the mid-1760s seems likely.

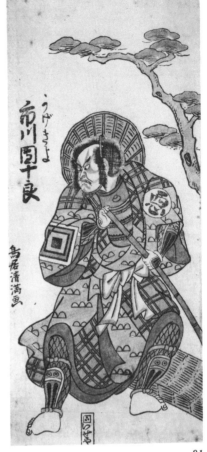

81

82 KIYOMITSU I

Title: SEGAWA KIKUNOJŌ II
Date: late 1760s
Technical: five-color *hosoban*, 29.5 × 13.7 cm.
Signature: Torii Kiyomitsu *ga*
Publisher: no mark
James A. Michener Collection, Honolulu Academy of Arts

This design has been identified elsewhere as Segawa Kikunojō II in the role of Kasaya Sankatsu in the 1768 production of *Kokyō no Torikaji,* but this assignment is uncertain. The famed *onnagata* appears as a young woman walking among chrysanthemums.

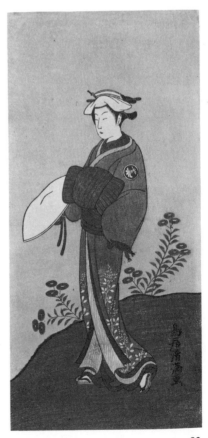

82

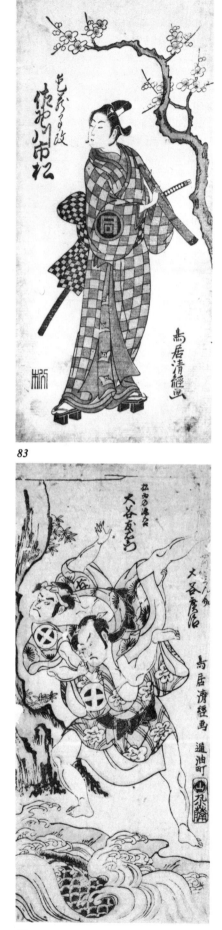

83

83 KIYOTSUNE (active 1750s-1770s)

Title: SANOGAWA ICHIMATSU II
Date: ca. 1767
Technical: three-color *hosoban*, 30.6 × 13.9 cm.
Signature: Torii Kiyotsune *ga*
Publisher: Matsu
James A. Michener Collection, Honolulu Academy of Arts

The actor, Sanogawa Ichimatsu II, holding a *shakuhachi*, is posed beside a flowering tree. The inscription is a reference to the actor's name assumption during the eleventh month of 1767.

84 KIYOTSUNE

Title: ŌTANI TOMOEMON AS MATSUI NO GENGO AND ŌTANI HIROJI AS GUNSUKE
Date: ca. 1770
Technical: three-color *hosoban*, 30.5 × 14 cm.
Signature: Torii Kiyotsune
Publisher: Tōri abura-chō Yama Maruko Fuji
James A. Michener Collection, Honolulu Academy of Arts

The *yakko* (samurai man-servant), Gunsuke, played by Ōtani Hiroji, is about to throw Matsui no Gengo, played by Ōtani Tomoemon, over his shoulders.

84

85 KIYOTSUNE

Title: SANOGAWA ICHIMATSU II AS FUSEYA
Date: 1771, eleventh month
Technical: three-color *hosoban*, 31.1 × 14.1 cm.
Signature: Torii Kiyotsune *ga*
Publisher: no mark
James A. Michener Collection, Honolulu Academy of Arts

The actor, Sanogawa Ichimatsu II, appears in the role of Fuseya, the younger sister of Makino Kojirō, in *Konohana Yotsugi no Hachinoki* given at the Ichimura-za in the eleventh month of 1771.

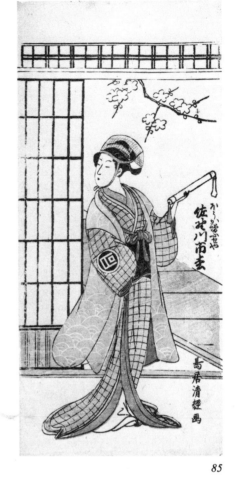

85

86 KIYOTSUNE

Title: MATSUMOTO KŌSHIRŌ AS ŌTOMO NO YAMANUSHI
AND ICHIKAWA DANZŌ AS HANYA GORŌ
Date: 1771, eleventh month
Technical: three-color *hosoban*, 28.6 × 13.4 cm.
Signature: Torii Kiyotsune *ga*
Publisher: no mark
James A. Michener Collection, Honolulu Academy of Arts

Matsumoto Kōshirō as Ōtomo no Yamanushi (top) and Ichikawa Danzō as Hanya Gorō are shown in a *shibaraku* scene from the 1771 Nakamura-za production of *Kuni no Hana Ono no Itsumoji*.

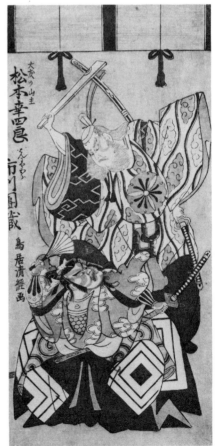

86

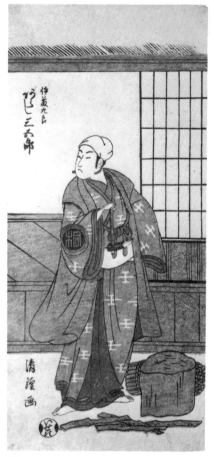

87

87 KIYOTSUNE

Title: ARASHI SANGORŌ II AS ITŌ KURŌ
Date: 1772, eleventh month
Technical: three-color *hosoban*, 40.4 × 14.1 cm.
Signature: Kiyotsune *ga*
Publisher: Iseki
James A. Michener Collection, Honolulu Academy of Arts

Arashi Sangorō II portrays Itō Kurō in the 1772 Morita-za production of *Izugoyomi Shibai no Ganjitsu*. He holds a small ax and stands by a chopping block where he has been splitting kindling.

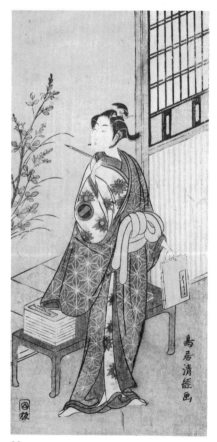

88

88 KIYOTSUNE

Title: ICHIKAWA MONNOSUKE II
Date: ca. early 1770s
Technical: full-color *hosoban*, 30.1 × 13.7 cm.
Signature: Torii Kiyotsune *ga*
Publisher: Urokogata-ya *han*
James A. Michener Collection, Honolulu Academy of Arts

The actor, Ichikawa Monnosuke, is seen as a young man with writing brush and book. Born in 1743, Monnosuke used the name Ichikawa Banzō in the 1760s, changing it to Monnosuke II in the eleventh month of 1770.

89 KIYOTSUNE

Title: ŌTANI HIROJI II
Date: ca. early 1770s
Technical: full-color *hosoban*, 31.6 × 14 cm.
Signature: Torii Kiyotsune *ga*
Publisher: no mark
James A. Michener Collection, Honolulu Academy of Arts

Ōtani Hiroji II is seen holding a lacquer box and standing beside a water tank.

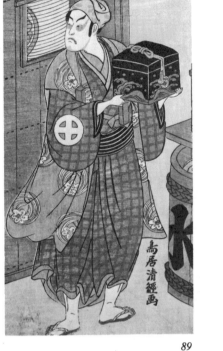

89

90 KIYOTSUNE

Title: SEGAWA TOMISABURŌ I AS OSHIZU A TOOTHBRUSH
SELLER
Date: 1774, first month
Technical: three-color *hosoban*, 30.7 × 13.9 cm.
Signature: Kiyotsune *ga*
Publisher: Suruga-*ya*
James A. Michener Collection, Honolulu Academy of Arts

The *onnagata*, Segawa Tomisaburō I, is seen in the role of the toothbrush seller Oshizu in the
1774 Ichimura-za production of *Yuikanoko Datezome Soga*.

90

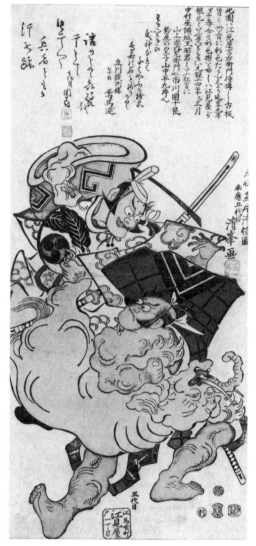

91

91 KIYOMITSU II (1788-1869)

Title: ICHIKAWA DANJŪRŌ I AS YAMAGAMI GENNAI
ZAEMON AND YAMANADA HEIKURŌ AS SUZUKA NO ŌJI
Date: 1812
Technical: handcolored *kakemono-e*, 48.7 × 22.5 cm.
Signature: "Genso Torii Kiyonobu *zu* Kiyomine *ga*" (Drawn by
Kiyomine after a design drawn by Torii Kiyonobu, the first of
the line)
Publisher: Murata (signing himself as Emi-*ya* V)
James A. Michener Collection, Honolulu Academy of Arts

Ichikawa Danjūrō I as Yamagami Gennai Zaemon and Yamanaka Heikurō as Suzuka no Ōji
are ripping apart an elephant in a scene from the 1701 Nakamura-za production of *Keisei
Ōshokun*. The design is a reduced copy of an earlier Torii *kakemono-e* published by the first
Emi-*ya* recording a performance given in 1701. (No. 13) The double inscription helps date the
work to 1812.

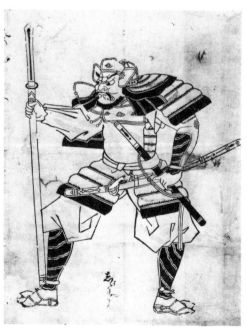

92

92 UNSIGNED

Title: THE WARRIOR SHISHI-Ō
Date: early 1660s
Technical: handcolored *ōban*, 37.7 × 28.5 cm.
Publisher: no mark
James A. Michener Collection, Honolulu Academy of Arts

An armor-clad Shishi-ō (the Lion King), whose courage and deeds are legendary, stands
fearlessly with his lance in hand. This design drawn in puppet style has been attributed on the
basis of style to the "Kambun Master" by Richard Lane.

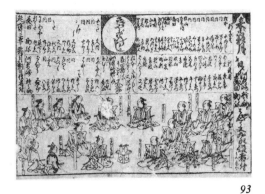

93

NSIGNED

ANZUKE

75, eleventh month

l: black and white horizontal sheet, 23.8 × 24 cm.

r: Hangi-*ya*

Michener Collection, Honolulu Academy of Arts

ed playbill is one of the oldest documents of its kind in existence. It announces the
f actors, especially new actors, who will be associated with the well-established actors,
aki Gonnosuke, Morita Kanya and Bandō Matakurō in the coming year. The picture
e inscription shows several of the actors in formal dress on a ceremonial occasion
o the opening of the new theatrical year. Another impression of this print, with similar
ace in the Rumpf Collection, is now owned by Helmut Kuhne in Zurich. The crude
g, casual printing and coarse paper give both prints an impression of age, but until
ybills of a similar technique and style are discovered, one must reserve the possibility
print may be a later fabrication.

NSIGNED

HUTENDŌJI'S PARTY

arly 1680s

al: handcolored album sheet, 35 × 23.1 cm.

er: no mark

. Michener Collection, Honolulu Academy of Arts

u is shown with his sword drawn at the outlaw, Shutendōji's banquet at Oeyama. The
irectly related to the *kimpira* books, theatrical narratives based on the life of the
e hero, Kimpira, which were originally published in the Osaka area in the second half
venteenth century. The style of art provides one of the well springs for the Torii
art.

94

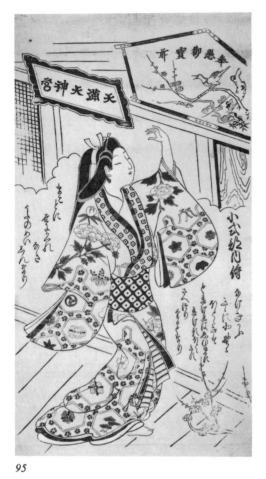

95

95 UNSIGNED

Title: THE POETESS KOSHIKIBU NO NAISHI AT
TEMMANGU SHRINE
Date: early 1680s
Technical: handcolored *kakemono-e*, 58.9 × 32.5 cm.
Publisher: no mark
Hiraki Collection, Riccar Art Museum; Important Object

The classic facial type of Sugimura's studies of beautiful women is observed in this superb print of which this is the only known impression. One of the earliest surviving broadsheets done in *kakemono* size, the work displays a freshness and grace not often observed in works of this early date. The style is certainly one of the wellsprings for the quiet decorative manner associated with the early art of Torii Kiyonobu I.

96

96 UNSIGNED

Title: (DAIFUKUCHŌ EHŌ NO YUKI KIOI UME NO YADO)
SANKAI NAGOYA (BALANCE SHEET OF THE THREE
HEROES MEETING)
Date: first month of Genroku 10 (1697)
Technical: black and white *eiri kyōgen bon* complete in one
volume; 24.0 × 15.7 cm.
Publisher: Kaifu-*ya*
Tokyo Geijutsu University Library

Sankai Nagoya was jointly written by Nakamura Akashi Seizaburō and Ichikawa Danjūrō I for the Nakamura-za New Year production of 1697. The plot concerns an attempt by the villain Ogimachi to overthrow the Shōgun, Horuo, his nephew and the son of the former Shōgun, Ashikaga Yoshimasu. The play marked the rise of the first Danjūrō as the leading performer at the Nakamura-za in Edo. A problem of artistic attribution attends this early work. Most of the illustration follow the cool, purely decorative style associated with the first Kiyonobu; a comparison of the portrait of Fuwa no Banzaemon played by Danjūrō I and Kiyonobu's portrait of the actor in the same role occurring in the signed picture book of 1700, *Fūryū Yomo Byōbu*, provides ample evidence for an attribution to Kiyonobu I. In contrast, however, the portrait of Shōki, the devil-queller, is a paradigm of Kiyomasu's early bombastic style. It is possible, therefore, that both artists had a hand in these splendid illustrations.

There is an interesting inscription included that helps shed light on the origin of the book's form: "This is the first publication with the complete story of the play including illustrations of the scenes." It has been suggested that this format was borrowed from the *kyōgen-bon* popular in the Kamigata area at the time. Some records suggest that the famous *shibaraku* sequence was first introduced by Danjūrō in the role of Fuwa Banzaemon in this production. Another tradition indicates that Danjūrō first performed the *shibaraku* sequence as Asahina Saburō Yoshihiae in the Morita-za production of *Asahina Hyaku Monogatari (Balance Sheet of One-hundred Ghost Tales of Asahina)*. The question remains open, but most scholars agree with the former identification.

Several other important acting *kata*, or sequences, were introduced in *Sankai Nagoya* and confirm the illustrations contained in the present picture book. These identifications are based on a careful reading of the text and are offered here in their entirety for the benefit of the specialist. (see page 112)

97 UNSIGNED

Title: TSUWAMONO KONGEN SOGA
Date: fifth month of Genroku 10 (1697)
Technical: black and white *eiri kyōgen bon* complete in one
volume; 22.6 × 15.6 cm.
Publisher: Kaifu-ya
Tokyo Geijutsu University Library

Tsuwamono Kongen Soga was written by Nakamura Akashi Seizaburō and Ichikawa Danjūrō I
for presentation at the Edo Nakamura-za in the fifth month of 1697. The plot concerns the
famous Soga brothers, Gorō and Jūrō, and their attempt to revenge their father's murder.
Based on Danjūrō's earlier *Kongen Soga* of 1688, but with considerable variation and many
hedonistic touches that were typical of the Genroku era, the play was an immediate success.
The illustrations for the *eiri kyōgen bon* are considered by Japanese critics to be particularly well
drawn and the book is generally conceded to be the best surviving example of its kind.

A similar problem in attribution attends this work as with *Sankai Nagoya*. While the majority
of illustrations are done in the more purely decorative style of Kiyonobu, a few follow the
forceful boldness of Kiyomasu's early style. This is particularly true in the case of the
illustrations of Gorō uprooting bamboo, which is closely related to a signed *kakemono* by
Kiyomasu of the same subject. It should be pointed out that any attribution at this distance is
tenuous. Evidence suggests that two other Torii artists may have been active at this time: Torii
Kiyomoto, Kiyonobu's father, and the newly-discovered Torii Kiyotaka, a teacher of Kiyonobu.
Unfortunately no signed art by Kiyotaka or Kiyomoto is known to survive on which a stylistic
comparison could be made.

Space has been taken here to describe the content of the illustrations accompanying this
important early book. (see page 113)

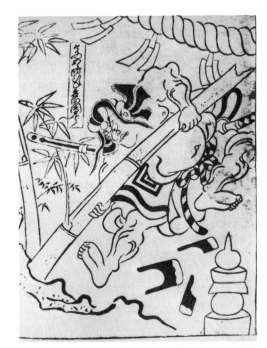

97

98 UNSIGNED

Title: KANTŌ KOROKU
Date: third month of Genroku 11 (1698)
Technical: black and white *eiri kyōgen bon* complete in one
volume; 24.4 × 16.0 cm.
Publisher: Kaifu-ya
Tokyo Geijutsu University Library

The play's author has borrowed from a popular Edo period story the colorful personality of
Koroku, a horse dealer and singer of *Kouta* (special songs), and has transformed the character
into a samurai. The main plot concerns a triangle situation between Koroku's mistress Tsuyu no
Mae, Koroku, and his wife Kumihime.

Stylistically, this work is surely Torii. One of its illustrations is repeated with variation as a
single sheet by Torii Kiyonobu—the portrait of Tsuyu no Mae dancing before Tadasu Shrine
(see No. 2). Other illustrations are done in a style close to Kiyomasu, making any convincing
attribution impossible. A description of the content of each illustration follows: (see page 115)

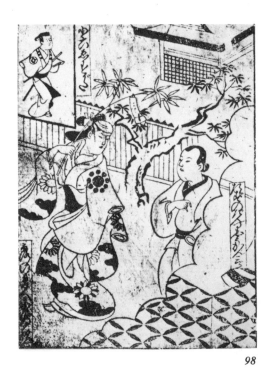

98

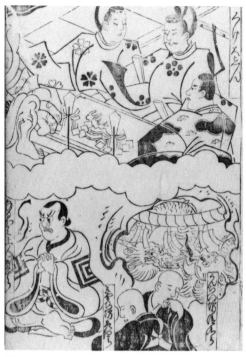

99

99 UNSIGNED

Title: GENPEI NARUKAMI DENKI
Subtitle: KUMONO TAEMA NAGORI NO TSUKI
Date: eighth month of Genroku 11 (1698)
Technical: black and white *eiri kyōgen bon* complete in one
volume; 22.0 × 15.6 cm.
Publisher: Kaifu-*ya*
Tokyo Geijutsu University Library

Ichikawa Danjūrō I revised his Narukami play for the Nakamura-za production of the ninth
month of 1698 under the title *Genpei Narukami Denki*. The story survives in various forms to this
day and is regarded as one of the best kabuki plays of the Genroku era. Narukami, played by
Danjūrō, is a holy recluse who had captured the god of rain (Ryūjin) and confined him in a
rock pool so that no rain would fall. He did this to take revenge on the Emperor who had
refused his petition. The main plot concerns Narukami and Kumono Taema, a beautiful lady
who had been sent to Narukami's mountain retreat to seduce him and to let the rain god
escape. The illustrations are well done and reveal the same combination of Torii styles that
attend other kabuki books of the same date, making attribution difficult. A description of the
illustrations follows: (see page 116)

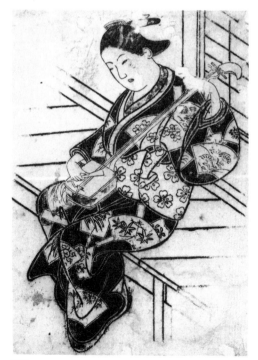

100

100 UNSIGNED

Title: COURTESAN PLAYING SAMISEN
Date: early 1700s
Technical: handcolored sheet, 32 × 22 cm.
James A. Michener Collection, Honolulu Academy of Arts

This single-sheet design, showing a courtesan playing a *samisen*, has been attributed by past
critics to the Kyoto artist, Omori Yoshikiyo. He was a follower of Hambei, who worked in the
early 1700s, and was apparently influenced by the Edo prints of Moronobu, the Torii and
Masanobu.

101 UNSIGNED

Title: KABUKI ACTOR
Date: early 1700s
Technical: handcolored sheet, 31.5 × 20.4 cm.
Publisher: no mark
James A. Michener Collection, Honolulu Academy of Arts

This design, showing an actor with two swords, has also been attributed by past critics to the Kyoto artist, Omori Yoshikiyo, based on a comparison with his signed illustrations appearing between 1703 and 1716. The cool decorative style of the early Torii is observed in this work.

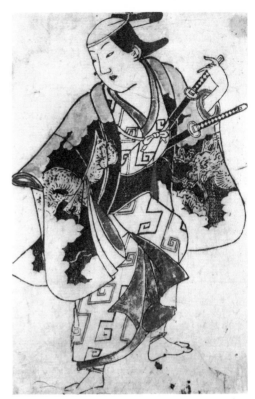

101

102 UNSIGNED

Title: IWAI SAGENTA AS A COURTESAN OF SHIMBARA AND KATSUYAMA MATAGORŌ AS KASHIWAGE SAKYŌ
Date: 1700, eleventh month
Technical: handcolored *hosoban*, 32.6 × 15.7 cm.
Publisher: Iga-*ya*
Hiraki Collection, Riccar Art Museum; Important Art Object

This fine print was formerly identified with the 1701 Ichimura-za production of *Jito Tenno Miyako Watamashi* in which Iwai Sagenta appeared in the role of Yuki Hime and Katsuyama Matagorō in that of Hanamura Takiguchi (cf. Shibui Kiyoshi, *Ukiyo-e Zenshu: Shoki Hanga Hen*). The identification offered in the official catalogue of the Hiraki Collection by Seichiro Takahashi seems more tenable and we have followed this assignment here. Both the costume and pose of Sagenta are suggestive of a courtesan's role, while the travel costume of Matagorō recalls the chance meeting and subsequent love affair of a Shimbara courtesan with Kashiwage Sakyō in *Shogei Hatsukoi Sanryaku no Maki*. This play was performed by these same actors at the Ichimura-za in the eleventh month of 1700. The charm and vitality of this work with primitive woodblock carving and handcoloring is in keeping with this early date. The print follows the calm, purely decorative style associated with the early art of Torii Kiyonobu I.

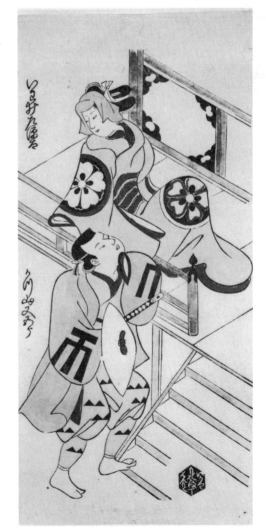

102

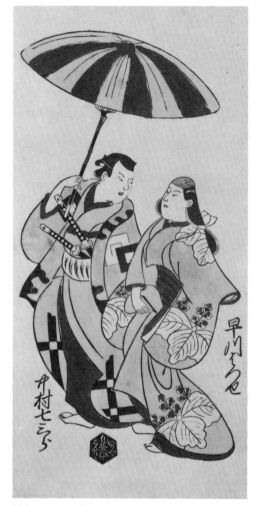

103

103 UNSIGNED

Title: NAKAMURA SHICHISABURŌ AS CHIHARA SAKON
NO SUKE AND HAYAKAWA HATSUSE AS THE COURTESAN
OKUNI
Date: 1702, eighth month
Technical: handcolored *hosoban*, 32.5 × 15.8 cm.
Publisher: Iga-*ya* Motohama-chō *hammoto*
Hiraki Collection, Riccar Art Museum; Important Art Object

Nakamura Shichisaburō, identified by inscription, appears in the role of Chihara
Sakon-no-Suke and Hayakawa Hatsuse, also identified by inscription, appears as the courtesan
Okuni. Shichisaburō, the eloquent actor of Kamigata kabuki, carries an umbrella over the
onnagata Hatsuse. The scene comes from the *michiyuki* (traveling) sequence in the 1702
Yamamura-za adaption of *Shida Kaikeizan.* The work is done in the full curvilinear style of the
first Kiyonobu. The bold draftsmanship has a rhythmic quality similar to painting.

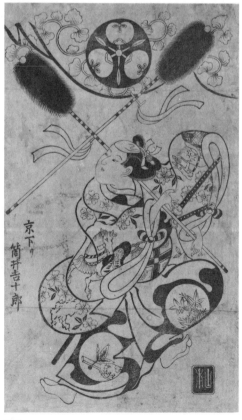

104

104 UNSIGNED

Title: THE ACTOR, TSUTSUI KICHIJŪRŌ IN THE YARI-ODORI
(SPEAR DANCE)
Date: 1704
Technical: handcolored *kakemono-e*, 54.5 × 33.5 cm.
Publisher: Seal only: Yamamoto (the mark of Maru-*ya* Yamamoto
Kohei)'
Collector's Seal: "nobu" enclosed
Watanabe Collection, Tokyo

According to record, Tsutsui Kichijūrō arrived in Edo from Kamigata in Hōei 1 (1704). This fine
print was probably published to commemorate his first Edo performance of the classic *Yari-odori,*
presented shortly after his arrival. The inscription, "Kyō kudari Tsutsui Kichijūrō (Tsutsui
Kichijūrō lately came down from Kyoto) offers firm support for this identification. A different
state of this subject, by a different publisher, is in the collection of the Museum of Fine Arts,
Boston; both prints were apparently owned by the same collector. The print follows the full
decorative style of Torii Kiyonobu I.

106 UNSIGNED

Title: SOGA GORŌ AND FUDŌ MYŌŌ
Date: ca. 1715
Technical: handcolored horizontal *ōban*, 25.6 × 35.0 cm.
Publisher: no mark
Watanabe Shōzaburō Collection, Tokyo

This print has been identified elsewhere as the popular dialogue between Ichikawa Danjūrō I as Soga Gorō and Danjūrō's son, Kyūzō, as Fudō Myōō (alias Tsūkibō) from the 1697 Nakamura-za production of *Tsuwamono Kongen Soga*. The absence of the actor's *mon*, however, suggests that this print is not an illustrative record of a specific performance, but is rather one merely inspired by the famous kabuki scene. Stylistically, the print seems close to Kiyomasu's work in the early 1710s.

106

107 UNSIGNED

Title: KIRINAMI TAKIE AS TAKIGUCHI'S YOUNGER SISTER, IKUSHIMA SHINGORŌ AS YORIMASA AND ICHIKAWA DANJŪRŌ II AS HAYATA (?)
Date: 1712 (?)
Technical: handcolored *hosoban*, 30.4 × 15.6 cm.
Publisher: Sakai-chō Nakajima-*ya* hammoto
James A. Michener Collection, Honolulu Academy of Arts

The *onnagata*, Kirinami Takie appears as Takiguchi's younger sister, while Ikushima Shingorō and Ichikawa Danjūrō II perhaps portray Yorimasa and Hayata, in the 1712 Yamamura-za production of *Fukuwara Yunzei Yorimasa*.

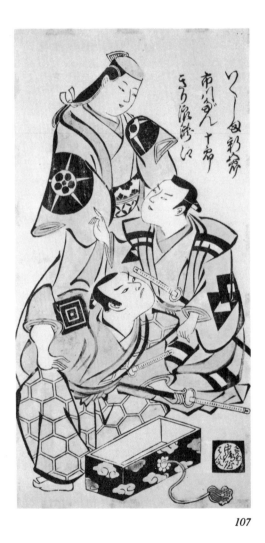

107

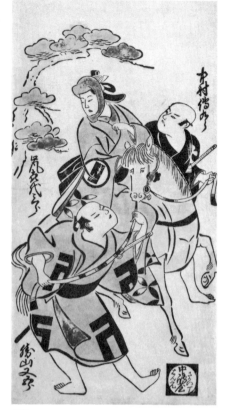

108

108 UNSIGNED

Title: NAKAMURA DENKURO, ARASHI KIYOSABURŌ, AND KATSUYAMA MATAGORŌ
Date: ca. 1711-1713
Technical: handcolored *hosoban*, 30.4 × 15.5 cm.
Publisher: Sakai-chō Nakajima-*ya hammoto*
Hiraki Collection, Riccar Art Museum; Important Art Object

Although it has tentatively been suggested that this print records the 1708 Nakamura-za production of *Miyasudokoro Monomi Guruma,* there is no firm support. The three actors noted, all identified by *mon* and inscription, appeared together in almost ten plays from the fall of 1708 to the fall of 1709, and again from the eleventh month of 1711 to the fifth month of 1713. Based on the style and vigorous clean line of this print, a play within this second period of the actors' activity seems more likely. The work has been traditionally attributed to the first Kiyonobu, but a certain gracefulness in its rendering suggests that the design could be by Kiyomasu working in Kiyonobu's full, decorative style.

109

109 UNSIGNED

Title: MURAYAMA HEIEMON AND TOMIZAWA HANSABURŌ
Date: 1710-1713
Technical: handcolored *hosoban*, 31.5 × 14.2 cm.
Publisher: Hangi-*ya* Shichirōbei
James A. Michener Collection, Honolulu Academy of Arts

The actors, Murayama Heiemon and Tomizawa Hansaburō, are depicted in a scene from an Edo kabuki play probably presented sometime between 1710 and 1713 when the two actors appeared together. Stylistically the print is close to Torii Kiyonobu I or the quieter style of Torii Kiyomasu I.

110 UNSIGNED

Title: YAMANAKA HEIKURŌ AS THE OLD WOMAN OF
KUROZUKA AND ICHIKAWA DANJŪRŌ I AS GONGORŌ
Date: 1714, eleventh month
Technical: handcolored *hosoban*, 30.3 × 15.3 cm.
Publisher: Sakai-chō Nakajima-*ya hammoto*
Hiraki Collection, Riccar Art Museum; Important Art Object

Yoshida Teruji (cf. *Ukiyo-e Zenshū: Shoki Hanga*) connected this print with the 1714
Nakamura-za production of *Banmin Daifukuchō* and the roles noted above. Yoshida postulated
that the artist combined into one print two scenes in which the actors appeared separately.
Such an occurrence is particularly common in the *eiri kyōgen bon* of the period. Traditionally this
print is attributed to Torii Kiyonobu I, but the powerful, violently distorted design executed
with a fine calligraphic line is a paradigm of Kiyomasu's bombastic style. It should be noted,
moreover, that Kiyomasu's famous *shibaraku* portrait (No. 25) probably comes from the same
performance being recorded here.

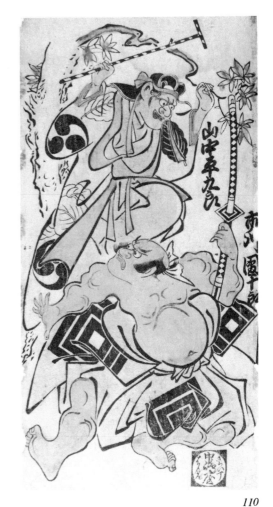

110

111 UNSIGNED

Title: ICHIMURA TAKENOJO, ICHIMURA TOMAŌ, AND
WAKABAYASHI SHIROGORO
Date: ca. 1715
Technical: handcolored *kakemono-e*, 57.5 × 32.8 cm.
Signature and Seal: Kiyomasu; Kiyomasu (in question)
Publisher: Komatsu-ya (in question)
Hiraki Collection, Riccar Art Museum

Ichimura Takenjo (left) and Wakabayashi Shirogoro (right) appear in identical costumes beside a
mochi pounder; Shirogoro holds a mallot used in the making of the New Year rice cake. The
onnagata, Ichimura Tamaō stands between them elegantly posed with an open fan in her right
hand. All three actors are identified by *mon* and inscription. From an unidentified New Year
play, the style of this fine print suggests the art of Torii Kiyomasu I, working in the mid-1710s.
Although signed and sealed Torii Kiyomasu, the attribution cannot be confirmed since the
bottom portion beginning with the character "masu" has been reconstructed in recent times. No
other impression of the subject is known to survive.

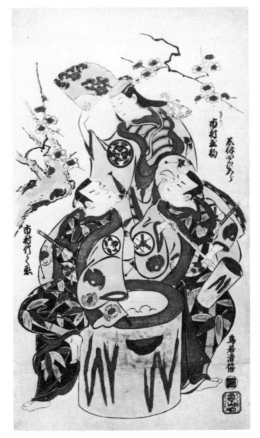

111

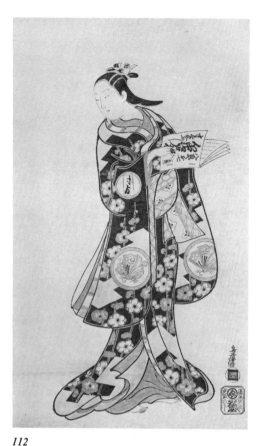

112

112 UNSIGNED

Title: SANJŌ KANTARŌ II AS YAOYA OSHICHI
Date: 1718
Technical: handcolored *kakemono-e*, 54.6 × 32.4 cm.
Signature and Seal: Torii Kiyonobu, Kiyomasu (Due to the discrepancy in signature and seal, the attribution of this print cannot be determined with certainty)
Publisher: Komatsu-*ya* Yushima Tenjin Onnazaka no shita
Clarence Buckingham Collection, Art Institute of Chicago

Sanjō Kantarō, identified by his butterfly *mon* appears as Yaoya Oshichi in the drama *Nanakusa Fukuju Soga* performed at the Ichimura-za in the first month of 1718. He holds a book entitled *Shinjū Edo Zakura (Double Suicide, the Cherry of Edo)* and wears the *jōmon* (fixed crest) of the first actor to create the role—the "love letter crest" of Arashi Kiyosaburō. The actor's hairpin is inscribed *Kichi,* a reference to Oshichi's lover, Kichisa, in the above-mentioned play. The identification is substantiated in both the *Kabuki Nempyō* and the *Hana no Edo Kabuki Nendaiki,* where even the use of Kiyosaburō's *jōmon* is specifically mentioned. This print, along with another surviving example of a different subject (Museum of Fine Arts, Boston), raises several interesting questions due to the fact that they are both sealed Kiyomasu but signed Kiyonobu. While critics attribute the present print to Kiyomasu I, the second work, from the play and same publisher, is given to Kiyonobu I. The inconsistency in seal and signature is blamed on an engraver's error, but if we are to accept these alternate attributions as correct, then the errors in each print are diametrically the opposite ones—a rather unlikely occurrence indeed. Both prints are among the last dated works in *kakemono-e* size to be produced before the sumptuary laws of the Kyōho era became truly effectual.

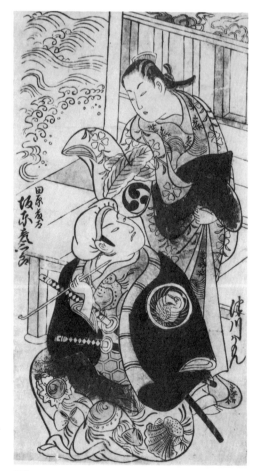

113

113 UNSIGNED

Title: BANDŌ HIKOSABURŌ AS TAWARA TŌDA AND TSUGAWA KAMON AS A WIFE
Date: 1728, first month
Technical: handcolored *hosoban* with lacquer, 29.1 × 15.7 cm.
Publisher: no mark
James A. Michener Collection, Honolulu Academy of Arts

Bandō Hikosaburō as Tawara Tōda holds a long pipe and kneels before the standing figure of Tsugawa Kamon, the wife of either Sumitomo or Urashima in the 1728 Ichimura-za production of *Urashima Tarō Shichise no Mago.* The design is in the style of Torii Kiyonobu II.

114 UNSIGNED

Title: SOGA NO GORŌ AND KOBAYASHI ASAHINA
Date: late 1720's
Technical: handcolored *hosoban* with lacquer, 31.9 × 15.2 cm.
Publisher: Shimmei-mae Izutsu-*ya*
James A. Michener Collection, Honolulu Academy of Arts

In the famous armor-pulling incident, Asahina restrains the impetuous Gorō from attacking Kudō Suketsune prematurely. The faces of the two men are theatrical, but the print does not represent a stage performance. The drawing and especially the color of the print suggest a date in the 1720's.

114

115 UNSIGNED

Title: ONOE KIKUGORŌ AS HANSHICHI AND SAWAMURA SHIGENOI AS OHANA
Date: 1745, third month
Technical: two-color *hosoban*, 30.7 × 14.7 cm.
Publisher: no mark
James A. Michener Collection, Honolulu Academy of Arts

Onoe Kikugorō (left) and Sawamura Shigenoi as Hanshichi and Ohana stand beside a fence with large banners in the 1745 Ichimura-za production of *Satogayoi Fujimi Saigyō*. The banner at the left reads Soga Matsuri (Soga Festival). Three other *hosoban* designs for this play are all signed Kiyonobu, and this one may also have been designed by the same artist.

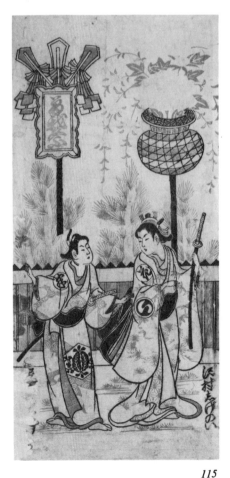

115

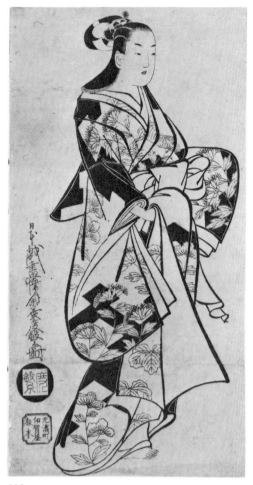

116

116 OTHER MASTERS OF THE PRIMITIVE PERIOD

Title: COURTESAN
Date: ca. 1710
Technical: black-and-white *kakemono-e*, 56.3 × 29.5 cm.
Signature and Seals: Kaigetsu matsuyō Dohan *zu;* Dohan
Publisher: Moto-hama-chō, Iga-*ya*, *hammoto*
Hiraki Collection, Riccar Art Museum; Important Art Object

On the basis of the decoration on the kimono, Kiyoshi Shibui cautiously matched all the extant Kaigetsudō prints with the months of the year and concluded that there were originally four sets of twelve, one for each month. The robe of the courtesan of this print, for example, is decorated with summer flowers traditionally associated with the month of July. Unfortunately, verification of this theory would require the close examination of all forty-eight designs and at this writing over one-half of these hypothetical prints are missing.

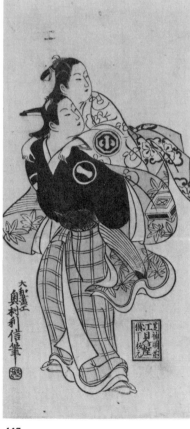

117

117 OTHER MASTERS OF THE PRIMITIVE PERIOD

Title: ICHIKAWA MONNOSUKE AND ARASHI WAKANO
Date: ca. early 1720s
Technical: handcolored *hosoban*, 31 × 14.3 cm.
Signature: Okumura Toshinobu *hitsu*
Seal: Not satisfactorily deciphered
Publisher: Shiba shimmei-mae, Emi-*ya*, yoko-chō, *hammoto*
James A. Michener Collection, Honolulu Academy of Arts

Little is known of Okumura Toshinobu (active ca. 1717-1740's) who sometimes used the art name Kakugetsudō. For many years, regarded as the son of Masanobu, recent dating of his prints renders this identification unlikely. Most of his work in *urushi-e* shows his preference for strong color and powerful sense of movement. Like Masanobu, his apparent contemporary, his art reflects the influence of Torii Kiyonobu I.

Shown here is Ichikawa Monnosuke eloping with the *onnagata*, Arashi Wakano, in an unidentified play of the early 1720s.

118 OTHER MASTERS OF THE PRIMITIVE PERIOD

Title: SANOGAWA ICHIMATSU AS HISAMATSU
Date: ca. 1745, ninth month
Technical: handcolored *hashira-e*, 68.5 × 16 cm.
Signature: Senkadō Nishimura Shigenaga *hitsu*
Publisher: Urokogata-*ya*
James A. Michener Collection, Honolulu Academy of Arts

Shigenaga worked during the Kyōhō (1716-1736) and the Hōreki (1751-1763) eras, designing many urushi-e and a few benizuri-e. His early work during the Kyōhō era is mostly of kabuki actors, done in the pervasive Torii style. He eventually created a new style, however, combining the sensual and more flowing character of the art of Nishikawa Sukenobu and Okumura Masanobu with his own early Torii forms.

Ichimatsu is shown concealing a letter addressed "Somoji" (to you). His costume is identical to another portrait of Ichimatsu with a love letter signed Toyonobu (AIC, Vol. I, No. 19, p. 208), and is strikingly similar to a portrait of Onoe Kikugoro I with a love letter in the Michener Collection. The Masanobu portrait seems to be firmly identified as the page Kichisaburō in a play performed in the spring of 1744. Both the Shigenaga and Toyonobu portraits have been identified as the role of Hisamatsu in a play performed a year earlier in the spring of 1743. The theatrical records describe this scene as a lover's journey and describe Hisamatsu in high sandals with a bundled *furoshiki* upon his back. It seems more likely therefore that this print is either a fictitious depiction of the handsome young actor in the popular role of Kichisaburō or a genuine portrait of him as the clerk Hisamatsu in the 1745 Nakamura-za performance of *Higashiyamadono Takara no Ishizue*. In either case, both prints seem to follow rather than precede Masanobu's print.

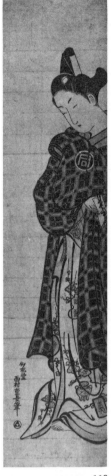

118

119 OTHER MASTERS OF THE PRIMITIVE PERIOD

Title: FIXING A LOVE POEM TO A CHERRY BRANCH
Date: 1740's
Technical: handcolored vertical *ōban*, 50.7 × 23.1 cm.
Signature and Seals: Meijōdō Ishikawa; Shuha Toyonobu;
Shuha Toyonobu; Ishikawa Shi; Toyonobu.
Publisher: Urokataga-*ya*
*Hiraki Collection, Riccar Art Museum; Registered Important Cultural
Property*

Ishikawa Toyonobu (1711-1785) is said to be a late name of the artist Nishimura (Magosaburō) Shigenobu, the chief pupil of the distinguished artist, Nishimura Shigenaga, who is listed in some sources as a student of Torii Kiyonobu I.

Theory has it that around 1747, he changed his art name from Nishimura Shigenobu to Ishikawa Toyonobu (cf. *Kono hana*, 14). This name change is by no means certain, however, and stylistic differences between prints signed Shigenobu and those signed Toyonobu make it difficult to reach a firm conclusion. His influence on his contemporary, Torii Kiyoshige prompted inclusion of this superb Hiraki Collection print—a masterpiece of intimate sensuality. The poem has been translated as follows:

> "On meeting again, there will be sorrows
> How fleeting are the Cherry blossoms."

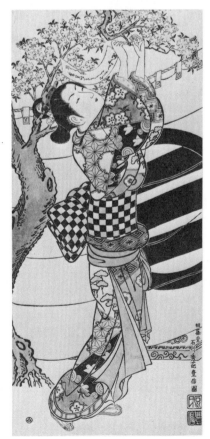

119

b a

96 UNSIGNED

a and b

Two young samurai, Nagoya Sanzaburō (Murayama Shirōji) and Yamana Saemon (Ōkuma Utaemon) are sword-fighting. Among the spectators is a blind man (actually an imposter) who takes part in the family trouble over an inheritance.

d c

c and d

Right: Danjūrō I (in the role of Fuwa no Banzaemon) and Nakayama Heikurō (in the role of Dazainojō) are fighting over an *ema* (votive picture dedicated to a shrine).
Left: Fuwa no Banzaemon (Danjūrō) has just been revived. A Shintō priest (Nakamura Denkurō) celebrates the good health of master Hamano. The two do a stylistic dance and *mie* here.

f e

e and f

A prostitute, Katsuragi (Hagino Sawanojō), visits the house of Mumezu Kamon, a Shintō priest (Nakamura Denkurō), to enquire after her lover, Nagoya Sanzaburō. Katsuragi is sitting on a cherry tree branch. (A similar version with the position of the figure reversed can be seen in the *Fūryū Shinhō Byōbu* series, No. 10.)

h g

g and h

Mumezu Kamon (Nakamura Denkurō) is trying to mediate between Fuwa no Banzaemon (Danjūrō) and Nagoya Sanzaburō; they are about to fight as a result of their swords touching accidentally. The scene takes place at Shimabara, the gay quarters.

i and j

Right: A prostitute, Katsuragi (Hagino Sawanojō), is combing the hair of Fuwa no Banzaemon (Danjūrō).
Left: Katsuragi and Nagoya Sanzaburō are searching for a place to commit suicide.

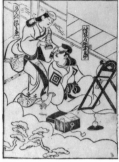
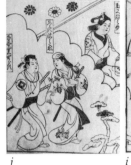

j *i*

k and l

Shōki (Danjūrō), the god that protects justice, is fighting with the evil spirit of Dazainojō (Nakamura Heikurō), while others look on.

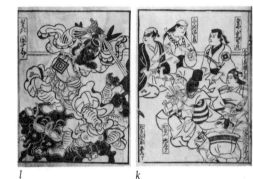

l *k*

97 UNSIGNED

a and b

Asahina (Nakamura Denkurō) tries to prevent Minamoto no Yoritomo (Murayama Genjirō) from sending two samurai, Giō (Okada Kurōzaemon) and Gorōmaru (Nakamura Segorō), to Soga for the purpose of attacking the Soga family.

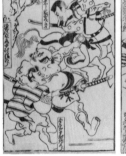
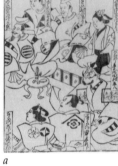

b *a*

c and d

Gorō Tokimune (Ichikawa Danjūrō) greets Kudō Suketsune (Nakayama Heikurō), the enemy who killed his father, at the house of Hakone no Bettō.

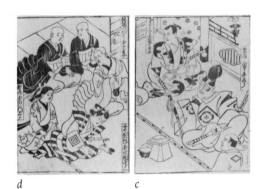

d *c*

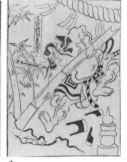

f e

e and f

Right: Gorō is given unusual strength by the god Fudō after thirty-seven days of ritual. The illustration here shows Gorō pulling out a bamboo on the twenty-seventh day of his ascetic practices.
Left: A little itinerant priest, Tsūriki Bō (Ichikawa Kyūzō), who is a personification of god Fudō Myōō, talks with Dōzaburō (Ichikawa Dannojō).

h g

g and h

Fudō Myōō (Ichikawa Kyūzō) stops Gorō (Ichikawa Danjūrō) and Asahina (Nakamura Denkurō) from fighting.

j i

i

Jūrō (Murayama Shirōji) makes a doll of Gorō (Danjūrō) and brings it to the residence of his mother who has disowned Gorō.

j

Two pursuers from Kamakura (where Minamoto no Yoritomo reigns) are attacking the Soga family at the house of Hōjō. This turns out to be a trick planned by Jūrō for the reconciliation between the mother and the son. The picture shows Chichibu no Rokurō (Sodezaki Tamura) and Hondo no Jirō (Takii Gen-emon) confronting Jūrō's attendant, Dōzaburō (Ichikawa Danjūrō), and Hōjō (Ōkuma Utaemon) at the entrance.

l k

k and l

The scene shows a party in progress. Gorō (Danjūrō) on the board and Asahina (Nakamura Denkurō) are displaying their strength by pulling the *kusazuri* (skirt) of Gorō's armor. This *kata* known as *kusazuri biki* became one of the special formal acting sequences. Wada no Yoshimori (Abura Kanroku), Jūrō (Maruyama Shirōji) and others are watching them.

98 UNSIGNED

a and b

A young samurai, Kataoka Yasaburō (Saruwaka Sanzaburō), younger brother of Yagorō (Danjūrō I), is protesting against the donation that the villainous priest, Tetsuganji (Tamura Heihachi), is forcing from the people.

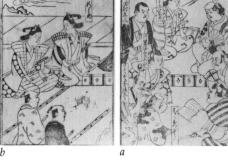

b *a*

c and d

In front of a teahouse on the grounds of a shrine, four people meet by accident; Kantō Koroku (Murayama Shirōji); his lover from Edo, Tsuyu no Mae (Sawamura Kodenji), Kataoka Yagoro (Danjūrō I) and his wife Tamakura (Hagino Sawanojō).

d *c*

e

A ghost of Koroku's wife Kumihime (Kiriyama Masanosuke), who died of jealousy, haunts the lovers Koroku (Maruyama Shirōji) and Tsuyu no Mae (Sawamura Kodenji), at Koroku's residence. Koroku decides to become a priest and go on a pilgrimage.

f

Tsuyu no Mae (Sawamura Kodenji), having lost Koroku, goes insane. In her wanderings she meets a priest, Genryō (Nakamura Kanzaburō), who tries to make love to her. However, when Genryō is prevented from doing so by the spirit of Koroku, he commits suicide.

f *e*

g and h

Kataoka Yagorō (Danjūrō) pretends to take part in a conspiracy of the villainous priest, Tetsuganji (Tamura Heihachi), who has returned to secular life and who now calls himself Ryōkonosuke. Yagorō's father Kataoka Gyōbuzaemon (Yamanaka Heikurō), and mother Tamakura (Hagino Sawanojō), enter complaining of their son's ingratitude to his master, Koroku.

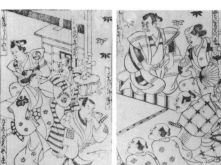

h *g*

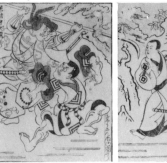
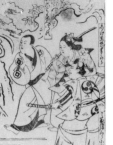

i and j

Gyōshin (Buddhist name of Yagorō) fights vengeful ghost to save his master, Koroku (Murayama Shirōji) and Koroku's attendant men Shigeo (Nakagawa Hanzaburō) and Yasaburō (Saruwaka Sanzaburō).

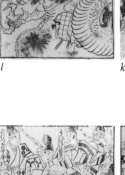

k and l

The titular deity of Koroku, Hikawa Myōjin, in the form of a gigantic dragon, suppresses the villain Ryōkonosuke (Tetsuganji) and his attendant men while Koroku and other watch.

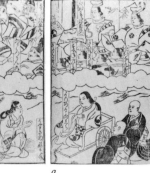

99 UNSIGNED

a and b

Top: Upon his visit to Kumano Shrine, Watanabe no Taketsuna (Maruyama Shirōji) finds a curious piece of wood. On this wood is drawn a picture of his master, Minamoto no Raikō (Sugiyama Yasozaemon), with nails driven through it. He also finds the name of Minamoto no Yorichika (Saruwaka Sanzaburō), son of Raikō. Undoubtedly, Yorichika is laying some sort of curse on his father Minamoto no Raikō.

Returning from his visit to Kumano Shrine, Watanabe no Taketsuna tells his master and his attendant men this story and shows them the wood at the residence of another son of Raikō, Minamoto no Yorinobu (Nakamura Kazuma).

Bottom: Usuginu (Kiriyama Masanosuke), a sister of Usui no Sadakage (Nakamura Seigorō), visits Minamoto no Yorichika in order to advise him to give up his conspiracy against his father, Raikō. She is dressed as a fisherwoman and gives him a fish, purposely recalling for the audience an old Chinese historical incident known by the name of the Chinese man involved, Tōshukō. At the same time Sakata no Kintoki (Yamanaka Heikurō) arrives to arrest Yorichika.

c and d

Top: A thunderstorm envelops the Imperial Palace, which frighten the Imperial Household to such an extent that they ask the priest, Kaizan, from the Shichidaiji (temple) to pray for its cessation. We see Kaizan (Danjūrō I) miraculously praying away the thunderstorm in the Imperial Palace. For this distinguished deed he is later given the name Narukami Shōnin (Narukami was the god of thunder) by the Emperor.

Bottom: Since Narukami's petition to the Emperor to save the life of Yorichika (who was arrested for his conspiracy) has been rejected, Narukami has captured the God of Rain in the form of a dragon (Ryūjin) and confined him in a rock pool. In this way he could cause a severe drought, taking revenge on the Emperor.

Kumo no Taema, the wife of Watanabe no Taketsuna, comes to Narukami's hermitage. She washes a cloth at the foot of the waterfall below the rock pool at the same time showing her legs to attract the attention of Narukami.

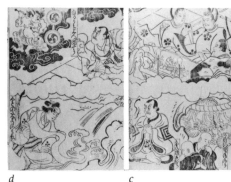

and f

Top: Realizing that he was tricked by Kumo no Taema, Narukami (Danjūrō I) became sick with the shame of having been deceived. Here, a young girl, Yatsugaki (Sawamura Kodenji), and her brother, Itsukimaru (Sodesaki Muranosuke), appear. The girl was engaged to Narukami before he entered the priesthood. Narukami is so ashamed of himself for being tempted and fooled that he commits suicide in front of his former fiancee.
Bottom: The spirit of dead Narukami haunts the family of Watanabe: Watanabe no Taketsuna (Murayama Shirōji), his wife Taema (Hagino Sawanojō), his son Takewaka (Ichikawa Kyūzō), and his stepfather Kintoke (Yamanaka Heikurō). Here Kintoki fights with the ghost of Narukami. Narukami forces Watanabe to divorce his wife by threatening the life of their son, Takewaka.

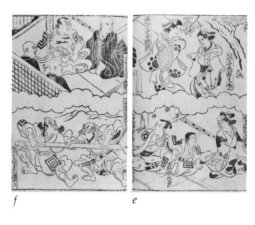

f e

and h

Top: At a party given by Minamoto no Raikō (Sugiyama Yasozaemon) the wrathful spirit of his son, Yorichika, who was executed for conspiracy, appears in the form of a gigantic foot but is subsequently driven off.
Bottom: This a scene from a special program for Hagino Sawanojō, one of the most popular actors of female roles at the time, to celebrate his officially becoming an "adult." The ceremony is call Gempuku and involves the shaving of the front lock of hair to symbolize the maturity of the actor involved.

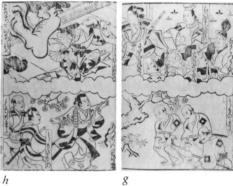

h g

Bibliography

Adachi, Toyohisa. "Primitive Fan Prints." *Ukiyo-e Geijutsu*, V. Tokyo, 1964.

Atsumi, Seitaro (ed.). *Nihon Gikyoku Zenshū: Kabuki hen*, 50 vols. Tokyo, 1928-1935.

Brown, Louise Norton. *Block Printing and Book Illustration in Japan*. London and New York, 1924.

Buckingham. *Catalogue of a Memorial Exhibition of Japanese Colour Prints from the Clarence Buckingham Collection* by F. W. Gookin. The Art Institute of Chicago, 1915.

Buckingham. *The Clarence Buckingham Collection of Japanese Prints: The Primitives*, edited by Helen C. Gunsaulus. Art Institute of Chicago, 1955.

De Gruyter, W. Joseph. *Van Moronobu tot Harunobu*. s'Gravenhage, 1952.

Einstein, C. *Der Frühere Japanische Holzschnitt*. Berlin, no date.

Engeki Gedai Yoran, edited by Nihon Hoso Kyokai. Tokyo, 1937, reprinted, 1954.

Ficke, Arthur D. *Chats on Japanese Prints*. New York, 1915.

Frankfurt. *Japanische Holzschnitte aus der Sammlung Straus-Negbaur in Frankfurt A.M. ausgestellt im Städel'schen Institut, beschrieben von Dr. Julius Kurth*. Frankfurt am Main, 1909.

Fujikake, Shizuya. *Nikuhitsu Ukiyo-e Senshu* (Master Works of Ukiyo-e Paintings), an illustrated catalogue of Hochi exhibition held at Tokyo in June, 1928. Tokyo, 1932.

Fujimura, Tsukuru. *Ukiyo-e*. Tokyo, 1924.

——————— . *Ukiyo-e no Kenkyū*, 3 vols. Tokyo, 1943.

Gookin, F.W. *Japanese Colour Prints, The Collection of Alexander G. Mosle*. Leipzig, 1927.

——————— . "Torii Kiyomasu," *Ukiyo-e*. Tokyo, 1940.

Gunsaulus, Helen C. (ed.). *The Clarence Buckingham Collection of Japanese Prints: The Primitives*. The Art Institute of Chicago, 1955.

Happer. *Catalogue of the Valuable Collection of Japanese Colour Prints and a Few Kakemono, the Property of John Stewart Happer, Esq*. Sotheby, Wilkinson & Hodge, London, April 26, 1909.

Hazama, Inosuke, Charles H. Mitchell, Isaburo Oka, Kiyoshi Shibui, Juzo Suzuki, and Teruji Yoshida. *Ukiyo-e Masterpieces*. Nihon Keizai Shimbun, Tokyo, 1969.

Hempel, Rose. *Japanische Holzschnitte, Sammlung Theodor Scheiwe, Münster*. Landesmuseum für Kinst und Kulturgeschichte, Munster, 1957.

Hillier, Jack. *The Harari Collection of Japanese Paintings and Drawings*. Boston Book and Arts, 1970.

——————— . "Sugimura Jihei," *Oriental Art*, V. London, Spring, 1959.

Hiraki Catalogue. See: *Masterworks of Ukiyo-e*.

Hirano, Chie. *Kiyonaga: A Study of His Life and Works with a Portfolio of Plates*. Boston, 1939.

Ihara, Toshiro (ed.). *Kabuki Nempyō*, 8 vols. Tokyo, 1956-1963.

——————— . *Kinsei Nihon Engekishi*. Tokyo, 1913.

——————— . *Meiji Engekishi*. Tokyo, 1933.

——————— . *Nihon Engekishi*. Tokyo, 1904.

Iizuka, Tomoichirō. *Kabuki Saiken*. Tokyo, 1926.

Inoue, Kazuo (ed.); revised by Sōshi Sakamoto. *Zōtei Keichō Irai Shoka Shūran*. Osaka, 1970.

Inoue, Kazuo. "Okumura Masanobu," *Ukiyo-e no Kenkyū*, II, no. 3. Tokyo, 1926.

——————— . "Torii Kiyonobu to Torii Kiyomasu," *Ukiyo-e no Kenkyū*, V, no. 3. Tokyo, 1923.

Inoue, Kazuo and Shōzaburō Watanabe (eds.). *Ukiyo-e Den*. Tokyo, 1931.

Jenkins, Donald. *Ukiyo-e Prints and Paintings: The Primitive Period. 1680-1745*. Chicago, 1971.

Kawaura, Ken-ichi. *Ukiyo-e Hanga Zenshū* ("Descriptive and Historical Album of Old Japanese Prints of the Ukiyo-e School"). Tokyo, 1918.

Keyes, Roger S. and Keiko Mizushima. *The Theatrical World of Osaka Prints*. Philadelphia Museum of Art, 1973.

Kikuchi, Sadao. *A Treasury of Japanese Woodblock Prints, Ukiyo-e*. Translated by Don Kenny. Crown Publishers, Inc., New York, 1968.

Kondo, Ichitaro, et al. *Illustrated Catalogues of Tokyo National Museum*. Tokyo, 1958.

Lane, Richard. "Erratum Note on Kiyomasu I," *Ukiyo-e Art*, XIV. Tokyo, 1966.

——————— . *Kaigetsudo*. Charles E. Tuttle Company, Rutland, Vermont and Tokyo, 1959.

——————— . "Koshoku Tsuya Komuso," *Harvard Journal of Asiatic Studies*, 1957.

——————— . "Review Article of the Buckingham Collection," *Harvard Journal of Asiatic Studies*, 1957.

——————— . "Saikaku's Contemporaries and Followers," *Monument Nipponica*, 1958.

——————— . "The Erotic Theme in Japanese Painting and Prints: Parts One, Two, Three." *Ukiyo-e*, No. 37. Tokyo, 1969.

Ledoux, Louis V. *Japanese Prints of the Ledoux Collection*, 5 vols. New York and Princeton, 1942-1951.

Link, Howard A. "Hishikawa Moronobu: The Consolidator of Ukiyo-e," *Orientations*. Hong Kong, May, 1972.

——————— . "Speculations on the Genealogy of the Early Torii Masters," *Ukiyo-e Art*. Tokyo, 1972.

——————— . "The Torii Enigma," *Ukiyo-e Art*, no. 13. Tokyo, 1968.

——————— . "The Art of the Kimono," *Orientations*, VI, no. 4. Hong Kong, April, 1975.

——————— . *Utamaro and Hiroshige: In a Survey of Japanese Prints from the James A. Michener Collection of the Honolulu Academy of Arts*. Otsuka Kogeisha. Tokyo, 1976.

Masterworks of Ukiyo-e, Memorial Exhibition of the Hiraki Collection. Tokyo, 1964.

Michener, James A. *Japanese Prints: From the Early Masters to the Moderns, with notes on the prints by Richard Lane*. Rutland, Vermont and Tokyo, 1959.

Mitchell, C. H., et. al. "Masterpieces of Ukiyo-e," *Ukiyo-e Art*, III. Tokyo, 1963.

Miyao, Shigeo (ed.). *Edo Kabuki Uchiwa-e Genroku-Enkyo hen*. Tokyo, 1964.

Mizutani, Futō. *Retsudentai Shosetsushi*. Tokyo, 1929.

Nakada, Katsunosuke. *Ehon no Kenkyū*. Tokyo, 1950.

Narazaki, Muneshige. "Fūryū Shihō Byōbu," *Ukiyo-e Geijutsu*, I. Tokyo, 1963.

Narazaki, Muneshige and Sadao Kikuchi. *Nikuhitsu Ukiyo-e*, Volume I: *Shoki Ukiyo-e (Ukiyo-e Paintings*, Volume I: *Early Ukiyo-e)*. Tokyo, 1962.

Nihon Ukiyo-e Kyōkai. *Ukiyo-e Kabuki Gashu*. Tokyo, 1927.

Noguchi, Y. *The Ukiyo-e Primitives*. Tokyo, 1933.

Ostasiatische Zeitschrift, 18 vols. Berlin, 1912-1943.

Ōmagari, Kuson. "Torii Kiyomasu no Setsu" *Ukiyo-e Shi* 5, pp. 37-42; 6, pp. 39-42.

Ōmagari, Kuson. "Torii Kiyomasu no Setsu" *Ukiyo-e Shi* 9, pp. 38-43; 10, pp. 37-41.

Ostier, L. *Primitifs japonais*. Paris, 1954.

Paine, Robert T. "The Masanobu Tradition of Courtesans of the Three Cities," *Ars Orientalis*, V. Baltimore, 1963.

Rumpf, Fritz. *Meister des Japanischen Farbanholzschnittes*. Leipzig, 1924.

_____ . "Keisei Ehon," *Ostasiatische Zeitschrift*. March-April, 1930.

_____ . See Straus-Negbaur

Saitō, Gesshin. *Zōho Ukiyo-e Ruikō*. Onchi Sōsho 4. Tokyo, 1891.

Sato, Tsurukichi. *Genroku Bungaku Jiten*. Tokyo, 1928.

Schraubstadter. *An Exceptionally Important Collection of Rare and Valuable Japanese Color Prints, the Property of Carl Schraubstadter*. American Art Galleries, New York, 1921.

Seidlitz, W. Von. *Geschichte de Japanischen Farbenholzschnitts*. Dresden, 1897.

_____ . *A History of Japanese Colour-Prints*. Heinemann, London, 1920.

Sekine, Kinshirō. *Honchō Ukiyo-e Gajinden*. Tokyo, 1899.

Shibui, Kiyoshi. *Edo no Hanga* (Prints of Edo). Tokyo, 1965.

_____ . *Estampes Erotiques Primitives du Japon (Genroku Kohanga Shuei)*, 2 vols., Tokyo, 1926-1928.

_____ . "Masanobu's Sumiye," *The Ukiyo-e no Kenkyū*, VI. March, 1929.

_____ . *Shoki Hanga*. Tokyo, 1954.

Shibui, Kiyoshi and Sadao Kikuchi. *Ukiyo-e Hanga*. Tokyo, 1964.

Stern, Harold. *Ukiyo-e Painting*. Freer Gallery of Art, Fiftieth Anniversary Exhibition. Smithsonian Institution, Washington, May 2, 1973.

Straus-Negbaur. Primitive Japanese Woodcuts: Twenty-five Prints from the Collection of Toni Straus-Negbaur, with an introduction by Professor Curt Glaser and a descriptive catalogue by Fritz Rumpf. Berlin, n.d.

Suzuki, Jūzō. *Nihon Hanga Benran*. Tokyo, 1962.

Suzuki, Jūzō, Shōkichi Harigaya and Osamu Ueda. *Ukiyo-e Bunken Mokuroku*. Tokyo, 1962. Revised edition published, 1972.

Takano, Tatsuyuki and Kanzō Kuroki. *Genroku Kabuki Kessaku-shu*, Taisho 14.

Tatekawa, Emba. *Hanano Edo Kabuki Nendaiki*. Tokyo, 1918.

Toda, Kenji. *Descriptive Catalogue of Japanese and Chinese Illustrated Books in the Ryerson Library of the Art Institute of Chicago*. Chicago, 1931.

Ukiyo-e Geijutsu, 4 vols. Tokyo, 1932-1935.

Ukiyo-e Kabuki gashū. Tokyo, 1927.

Ukiyo-e Ruikō, edited by Katsunosuke Nakada, Iwanami Bunko 2785-2786. Tokyo, 1941.

Ukiyo-e Taika Shūsei, 20 vols. Tokyo, 1931-1932.

Ukiyo-e Taisei, 12 vols. Tokyo, 1930-1931.

Vignier, Charles and Hogitarō Inada. *Estampes Japonaise Primitives . . . Exposees au des Arts Decoratifs en Fevrier 1909*, Catalogue dresse par M. Vignier avec la collaboration de M. Inada. Avant-propos par Raymond Koechlin. Paris, 1909.

Waterhouse, D. B. "The Floating World of Dr. Lane," *Ukiyo-e Art*, XIII. Tokyo, 1965.

_____ . *Harunobu and his age. The Development of Colour Printing in Japan*. London, 1964.

Yoshida, Teruji, et al. *Ukiyo-e Taisei*. Tokyo, 1930-1931.

_____ . *Ukiyo-e Taika Shūsei*. Tokyo, 1931-1932.

_____ . *Ukiyo-e Jiten*. (A Dictionary of Ukiyo-e), 3 vols. Tokyo, 1965.